Capital Women of Influence

About the Author

Ellen Gunning MA, MIAPR, FPRII, NUJ is a journalist, broadcaster and pr consultant. She presents the "Mediascope" programme each week on 103.2 Dublin City fm.

In summer 2009, she presented and produced the 13-week "Capital Women of Influence" series, broadcast on Dublin City fm. The series was made with the assistance of the Broadcasting Commission of Ireland.

Ellen holds an honours MA in Communications and Cultural Studies from Dublin City University. She has served as a Government appointed director to the boards of the National Concert Hall and the Central Council of the Irish Red Cross.

She is a director of the Irish Academy of Public Relations, and is author of *Public Relations – a practical approach* (2007). She is a Fellow of the Public Relations Institute of Ireland and former National Chairperson of the International Public Relations Association.

CAPITAL WOMEN OF INFLUENCE

Profiles of 13 Inspirational Irish Women

Ellen Gunning

The Liffey Press

Published by
The Liffey Press
Ashbrook House, 10 Main Street
Raheny, Dublin 5, Ireland
www.theliffeypress.com

A catalogue record of this book is
available from the British Library.

ISBN 978-1-905785-64-3

Printed in the United Kingdom by Athenaeum Press.

Contents

Preface

I HAVE BEEN PRESENTING THE weekly Mediascope programme on 103.2 Dublin City fm for a couple of years. The programme always takes a "holiday" for summer, but this year I wanted to challenge myself and put another programme in its place. I woke up one morning and thought – that's what I'd love to do, I'd love to interview successful, influential women.

So I sat down and wrote a "wish" list. Then I spoke to Dublin City fm to see if they would broadcast the show, and approached BCI (the Broadcasting Commission of Ireland) for grant assistance under their Sound and Vision scheme.

I contacted everyone on my wish list and, incredibly, they said YES. Then I began some serious research. The more I learned, the more fascinated I became.

So I approached David Givens in The Liffey Press. "There's a book in this," I said. "These are fascinating women. The entire country will want to read about them."

"I agree," he said. "Let's do it". So I started writing and the result is in your hands.

When I wrote the list, I deliberately wanted to choose from a cross-section of Irish life. I wanted to get the "personal" story of each of these women. I wanted to find out where they were born? How many brothers and sisters they had? What they wanted to be when they were growing up? Where they went to school? What their first job was? Who were the influencers in their lives? How did they get to where they are now? What achievement were they proudest of? What was the greatest challenge facing them? And how do they relax?

It is easy to tell you how they differ from each other. They are mixed in ages from mid-30s to mid-70s. They are mixed in marital status – some are partnered, some married, some separated, some widowed. Some have children, others don't. Some are very maternal, others not. They are not all the eldest or youngest or middle in the family. They come from large and small families. Some are incredibly house-proud, others have no interest. Although some had direct routes into their careers, others did not. They don't all believe that they have the balance right between work and home. Some would dearly love a "wife" – others already have one.

Anne Harris began writing because she was at home, alone, with a young baby and the four walls were closing in on her. She dallied briefly with teaching, but she says, she soon realised that if she was ever going to make a shilling it would be from journalism. She

worked in newspaper journalism – deviated into magazines, radio and television presenting – and came back to newspaper journalism and is now deputy editor of the *Sunday Independent*.

Betty Ashe left school with no ambitions. People didn't have ambitions in those days, she says. She got married, had children, got involved in the school and the youth club and the senior citizens club and, in time, became one of the most highly respected community activists in the city. She watched the destruction of the tenements in Pearse Street, which also destroyed the community. She has been working now for nearly 40 years on the re-generation of the south inner-city area, with incredible success.

Caroline Downey's life was changed utterly when she read about Ann Lovett, a 15-year-old mother who died, in Longford, giving birth to a child in a field in 1984. She was so upset that she created the Childline Annual Concert which raises hundreds of thousands of euro each year to fund the service which gives children someone to talk to.

Christina Noble has suffered great hardship in her life. Her mother died when she was only ten years old. Christina and her brothers and sisters were sent to industrial schools. She lived rough for a while, was raped and had a

child. She escaped to England but married a violent man with whom she had three children. She has been treated for a variety of very serious health problems over the years, but she resolutely concentrates on the positive. She formed the Christina Noble Children's Foundation and helps street children in Vietnam and Mongolia.

Danuta Gray always loved science subjects and took physics in her primary degree. She first came to Ireland for a job interview for Chief Executive of 02. Her second trip was with her family, to find a new home. She has worked all over the world and is quite unflappable. She says she "never, ever" gets work–life balance right, but she puts in long hours Monday to Thursday, and usually has tea with her husband and the boys of Friday evening to kick start "family time" for the weekend.

Eibhlin Byrne might still be teaching if there had been job-sharing options when her children were young. Instead, she returned to college to take a Masters, which led to her working with the homeless and street drinkers, which in turn led her into politics. She has just completed a term as Lord Mayor of Dublin and wants to find a way of continuing to contribute to the city's future.

Gina Quinn's mother was a big influence on her. A "matriarch", she believed that there was always another

way of asking a question if you didn't get the answer you wanted the first time. Gina worked in market research before developing and running Gandon Enterprises. This Dubliner is currently contributing to the life of the city through her role as CEO of Dublin Chamber of Commerce.

Ivana Bacik says that she was born with an argumentative streak – a great asset for someone who went into law! She has been leader of the student union in Trinity and is a qualified barrister in the UK and practicing barrister in Ireland. She is currently Reid Professor of Law at Trinity and author or co-author of numerous texts. An elected Senator, she is also the mother of two young girls and "likes having fun".

Maree Morrissey wanted to open a music school – but she couldn't find anyone to give her the money. She didn't fit into any "category". So she tried to find out how to become an entrepreneur. When she couldn't find the information, she launched Irish Entrepreneur magazine. This dynamo has fronted her own bands and backed Tori Amos and Van Morrison. She is mother to three-year-old Josh, European agent for the Naked Cowboy and a magazine publisher in Ireland and Dubai. She is quite determined that she will, eventually, open her music school.

Mary O'Rourke is one of the best known and most accomplished female representatives we've ever seen in this country. She held two Minister of State positions, has been a full Minister three times and was also Leader of the Seanad. She loves politics. It oozes from her pores. She really enjoys the role of public representative. She is very well read, has an opinion on any topic you care to mention and, incredibly for a politician, is quite wiling to share her opinion with you. Her husband Enda died eight years ago. They had been together since she was 18 years old and he was 20. She still misses him hugely.

Patricia Callan just thrives on challenge. When she went to college, she took Business, Economics and Social Studies because she had never studied any of them before in school! She still sets annual goals for herself, for business and personal life, and sticks to them. Although she doesn't put a focus on it, she is very conscious of being a woman in a male dominated area. She is Chief Executive of the Small Firms Association.

There are two things that strike you when you meet **Pauline Bewick**. The first is that she laughs a lot and has a great sense of humour, and the second is that she is incredibly open. Then you realise that she has been an artist all her life, is still incredibly prolific, has donated over 200 works to the State and has no intention

of slowing down – in fact, she's painting bigger now than she ever did.

Veronica Dunne used to write and perform plays in the garage. She charged the audience to attend so that her fellow "thespians" could have red lemonade and biscuits. An accomplished horsewoman, she sold her horse to raise money to travel to Italy to study opera singing. She was, perhaps, the first Irish opera singer to be given a contract with the Royal Opera House in Covent Garden. She has been teaching since the 1960s and officially retired from the stage in 1973. She still misses the smell of the greasepaint each evening at around 7.00 o'clock.

All of these women have achieved status and influence and respect in different fields of endeavour. All have different backgrounds, but all share a number of traits in common.

They are all passionate about what they do. They all work much longer hours that the standard nine to five. They are all supremely organised, in their business and home lives. They all get things done. They all see opportunities, not obstacles. They are all great talkers, and they enthuse as they talk. They are all generous in giving credit to others who helped them along the way: teachers, family members, influencers, past employers and friends. They are all, undoubtedly, high achievers.

They are also genuinely nice people. It really is a pleasure to have a cuppa and a chat with them. These women all have incredible energy levels, amazing ability and great personalities.

I am fascinated and inspired by each and every one of them. I hope you will be too.

Ellen Gunning
September 2009

To
Nellie, Peggy, Marie and Tony

The book is dedicated to the women who have influenced my life: my late mother Ellen (Nellie) Whelan, whose confidence in her children was unshakable; my mother-in-law and good friend, Peggy Gunning, one of the most amazing women I've had the pleasure of knowing; and my aunt, Marie Nicholson, who has always, unquestioningly, been there for me.

It is also dedicated to the man in my life – Tony Gunning – whose unwavering support makes everything possible.

Anne Harris

Anne Harris has worked in national newspapers, radio and television. She was editor of Image magazine before moving to the Sunday Independent where she is deputy editor. The Sunday Independent is Ireland's largest circulation Sunday newspaper.

"You wouldn't be in a job like this if you were going to count hours."

ANNE HARRIS THINKS OF HERSELF as a Cork city girl, although she was born in Donegal. Her mother was from Monaghan, and her father originally from west Cork. He was a surveyor with the customs and excise service, stationed in Donegal. When Anne was only three weeks old, and her brother a mere 20 months, the family left Donegal for Cork.

She grew up in the city, where her seven other siblings were born. In all, there are six boys and two girls in the family. She says she loved Cork. "I understand Cork very well, but I wouldn't see myself as a typical Cork person. I know a number of people whose mothers are from the north and whose fathers are from the south and it makes it that you never quite belong anywhere," she says. That slight detachment, she believes, allows her to appreciate Cork more.

She went to school in Ard Foyle, Blackrock, Co Cork and from there to University College Cork to study music with Sean O Riada, who had taken up the post of Lecturer in Irish Music at the college in 1963. O Riada was a very well known composer having, perhaps, reached the height of his fame with the release of the film *Mise Eire* in 1960 for which he had written the musical score. It, quite literally, caught the imagination of the nation.

Anne's father was very musical. Although he had no formal training, her father could take any instrument and pick out a tune on it. He had an ear for music and an innate ability with instruments. He was very keen that his children learn to play piano. "Almost too keen," says Anne, "it was a bit of a pressure." Anne learned and taught the others. She no longer plays though!

The family remain close knit to this day. Her mother passed away two years ago and, until then, there were fairly regular family reunions. Now, they hold email re-

unions on special occasions like her mother's birthday and for celebrations like Christmas. Two of her brothers now live in Canada, two more in California and the rest of the family is in Ireland.

As she became an adult, the women's liberation movement was really just taking off. Having six brothers was important to her when growing up because it meant that men and boys held no terrors for her. "I never saw men as the enemy," she says.

She was married young and moved from Cork to Dublin where her daughter was born. It was a big wrench for her. She didn't have any of the family supports in Dublin that she would have had in Cork. She found herself "alone in Dublin, with a small baby, and the four walls coming in on me". The year was 1967 and Anne was 20 years old.

The Shannon Free Zone had been opened almost a decade earlier, in 1959, to cater to companies which were producing mainly for the export market. It was quite close to Shannon airport.

EI Electronics opened in 1963. At that time it was owned by the General Electric Company, USA (or GE as it was better known). Following a management buyout (MBO) in 1988, it became a fully-owned private Irish company which produces Residential Fire Safety Products.

Back in 1967, a story about the plant had caught Anne's eye. There was a largely female workforce and

the company had banned unions. Anne was curious and wanted to learn more.

Her mother came to Dublin for a few days, so Anne asked her to mind the baby while she took the three-hour train journey to Ennis to investigate the situation first-hand and interview the women who were picketing outside.

When she got home that evening, she wrote an article and took it into the *Irish Press*. The Irish Press group had three papers at the time – the *Evening Press*, the *Sunday Press* and the *Irish Press*, which was one of three daily broadsheets published in Ireland. The others were the *Irish Times* and the *Irish Independent*. The *Irish Press* ceased publication in 1995.

Anne arrived into the newspaper at about 7.00 o'clock in the evening and asked to see the editor. She first met with his secretary, a man called John Horgan. (John Horgan went on to have a distinguished career as a journalist, author, educator and public representative. He was appointed Press Ombudsman by the Press Council of Ireland in 2007.)

She had to satisfy John Horgan's questions before she got to meet the editor, Tim Pat Coogan. Tim Pat Coogan (now one of Ireland's best known historical authors) was editor of the *Irish Press* for almost 20 years, from late 1960s until 1987. Coogan questioned her closely about what drove her to write the article, and then took it from her. It appeared in the next day's paper.

Anne continued to write occasional features when-
ever a story caught her imagination, and she could find
someone to mind the baby so that she could go off and
investigate.

Coogan obviously liked what she was writing. He
was a young editor, had a very dynamic style, was really
in touch with the mood of the day and was always look-
ing for new ideas and people.

Months later, he brought over a new women's editor
from London. Mary Kenny was a Dubliner who had left
school at 16 and, after living in France for a while, be-
came a reporter with the *London Evening Standard*.
There, she made quite a name for herself. Tim Pat
Coogan understood the dynamic that this young writer
would bring to his paper so he tempted her away from
the bring lights of London to the bright lights of the
Irish Press in Dublin. He also spoke to Mary about
Anne Harris, telling her, "there's someone I think you
should employ". Mary and Anne met, and Anne came
away with a new, full-time job.

Anne's first article was written when her daughter
was exactly six-months old. Six months later, Anne had
a full-time job. She loved working with Mary Kenny. It
was an exciting time – in newspapers and in Ireland.
Anne cites the television series *Mad Men* (a series about
advertising executives who work on Madison Avenue in
New York). She says that it doesn't do a bad job of rec-
reating the 1960s – particularly the smoking and drink-

ing habits that people had then. "We worked hard," says Anne, "but certainly people lived differently that time. It was a lot less structured."

During this time she won the highly coveted "Young Journalist of the Year" award for a series of articles she had written about travellers, or itinerants as they were called then. She says that, nowadays, it might seem like an obvious idea to go and live with some travellers for a week, but at the time it was considered quite original. She went to live with them and experienced, first hand, life on a campsite and begging for a living.

Working and having a small baby was challenging. Childcare wasn't well developed, and initially it was even difficult finding a crèche. But Anne juggled and, for a couple of years, it worked. She loved working in the office. It was a very interactive environment. There were news meetings, and features meetings, and ideas would be thrown out and discussed around the table, and then Anne (and others) would take off and research them and write about them. It was exciting, challenging and very sociable.

After a couple of years, Anne found that she had to give up the job. Her daughter was three years old, and the child had begun to get very upset going into the crèche. Anne stopped working full-time and became a freelance journalist.

Although people had told her that there would be plenty of work for her, she found working from home, alone, extremely difficult.

"They say the happiest women in the world are part-time working mothers," says Anne. "They have the joy of their children and the domestic, and they're not on a terrible treadmill and the part-time work brings them out where they are appreciated at another level, and the market makes them feel good," she says.

Working from home, however, was very different. "It's very hard to be confined to a house all day with children. It's one of the hardest things to do," she says. She also found it very difficult to actually get started each day. Instead of the buzz of daily newspaper meetings, she found that "suddenly, I'm at home, with a blank sheet, and a typewriter. I found it really hard. For a few years I really didn't do that much," she says.

So, she went back to college to become a teacher. Because she had patience with her small brothers and sister, perhaps, Anne's mother had always said that she was a "born teacher". It was something her mother thought she could do in her sleep.

Anne got a job teaching musicianship in Blackrock College. The college, originally opened in 1860 as the French College, sits on 56 acres of prime land in Blackrock in south county Dublin. It is one of the best established, most sought after and expensive private boys schools in the capital city.

Anne says that she was a terrible teacher. "If I could get one idea into their heads in the course of a class, that would be victory, but I was trying to give little lectures. I was terrible." The headmaster was pleased with her. She had good class discipline and could hold the attention of a class "but that was because I felt I had to absolutely fascinate them," she says. "It was like being Sarah Bernhard. I felt I had to go to the top of the class and perform for forty-five minutes." It was physically and mentally exhausting. During the week, she would not even go for a drink in the evening in case she had a hangover and it would affect her ability to hold their attention. She was constantly under pressure, in her own mind, to "perform".

"I was the worst teacher in Ireland," says Anne, and "it made me realise that if I wanted to earn a shilling ever, it would be in journalism. So I then became a good self-starter. It's something that happens. Self-starting is one of the most difficult things to instil in people – the ability to crank up and do it yourself. I can't pinpoint the moment at which I became a self-starter, its something to do with your own compulsion that you have to do something. I became much more disciplined. I began to be able to do it."

She says that it's about "taking responsibility for your own work and your own productivity. That is when you have crossed the Rubicon and you are able to function as a fully mature person," she adds.

This newly energised, responsible self-starter never had a dedicated office at home. She worked from the kitchen table. She would either ring an editor and say, "I've got an idea, would you like this piece?" or sometimes she would investigate and write the piece unsolicited, and then see if the editor would run it.

One of the features that stays in her mind from that time involved the oldest protestant school in Ireland, which was in the heart of Dublin. St. Patrick's Cathedral Grammar School was established by Edward VI in 1547. It has very close links to St. Patrick's Cathedral and is situated near Marsh's Library, the first public library in Ireland. It has been teaching mixed classes of boys and girls since 1969.

The children going to that school were getting stones thrown at them by, apparently, children from the local technical school. Anne knew that it was not in the nature of children "to be sectarian", so she went into the Liberties to investigate. The local people there were very upset about the carry on, and in particular she remembers a local man called John Gallagher who articulated the neighbourhood frustration at this behaviour.

There was a shadow over St. Patrick's at that time. Nobody could get to the bottom of it, however. Then it transpired that there was someone in the community, a protestant (but no one knew that), who was very shy and reluctant to stand up to these bullies. The situation was allowed to develop because someone in a position

of authority felt constrained and it only came to light because she was there, on the ground, asking questions.

Anne became a very successful freelance feature writer over the next decade, and she also did radio and television presenting. The radio series for RTE was called *Work and Money*. "I wasn't very comfortable in radio," she says. "I'd say I just barely acquitted myself."

She wasn't any more comfortable on television either. The chance to present came about when she was in RTE one day. RTE 2 had just started. A producer from BBC, Roger Brunskill, had come over and was doing camera tests for a new health series. Someone said to her that she should go over and do a camera test. She did it, in the lashing rain, and he offered her the job.

The programme was called *Positively Healthy*. It dealt with issues like alcoholism, smoking, migraines and corns on the feet. There were two presenters, herself and a woman called Delia Roche Kelly.

Delia Roche Kelly had great camera presence. "Roger would say to me, 'would you just do a piece to camera now about migraine' and I would stand in front of the camera and say, 'there's this terrible pain which afflicts so many people. It has no sinister connotations. It has no apparent systemic reasons. The Greeks considered it a gift from the gods.' I'd stand and I'd spiff and he'd say 'great' and that would be that."

"Then Delia would come along and he'd say cut – take one, take two – endless takes. The programme

would finally be aired and Delia would look stunning. She would have such presence. She would look amazing."

"I realised I was the useful one – the straight guy. The producer's whole focus was on this gorgeous looking woman, Delia Roche Kelly, who was delivering these sultry pieces to camera. I wasn't having a love affair with the camera. I was anxious to put a bit of information across and leave it at that. No, I wasn't a natural. I really was dreadful, it was nearly as bad as when I was a teacher," she says.

She did a couple of series of *Positively Healthy* "and then I got pregnant and was delighted to scoot off out of it." Anne was expecting her second child.

During this time, she had continued writing features for newspapers and magazines. Once or twice Clare Boylan, the editor of *Image* magazine, had asked her to write articles for her and she had done so.

One of the articles she wrote was about having her second child. It was called "The Gap". Anne's second daughter was born twelve and a half years after her first. "So, I had two 'only' children effectively," she says.

When her first child was born, Anne had really just taken it all in her stride. There was a baby in the pram at home at the time, so having a baby around didn't seem at all strange to her. She just put the child on her hip and took her everywhere. That just seemed like the normal thing to do. In fact, she can't remember ever

winding her daughter. She was relaxed and the child was relaxed.

When her second child was born, however, it was an entirely different sensation. Anne was tense and nervous, and her second child was colicky.

"It was extremely difficult. I'd got used to life without a baby around. I'd got used to working a lot. Suddenly I had a baby, and the baby was demanding and windy. The other thing was I'd fallen head over heels in love with the baby and didn't want to do anything else except be with the baby. I felt I wanted to take her and run away to a monastery with her. So it was a big shock."

She wrote an article about the experience for *Image* and began writing fairly regularly for them after that.

One day Clare phoned and said that she was going to take time off to write a novel. "I'll be absent from the office every week for a few months, would you occasionally come in and stand in my place and be editor?" she asked Anne. Things happen like that when you're a freelance, she says, opportunities just arise. So she went into the office and began commissioning articles the way she had known Clare to do it.

What started as a temporary assignment soon became full time when Clare decided that she was not returning, she was going to become a novelist. (Clare Boylan went on to become one of the country's most prolific writers producing seven novels, three collections of

short stories and two anthologies before her death in
2006.)

The magazine rang to ask Anne if she would edit full
time but she wasn't keen because her daughter hadn't
yet started school and she was reluctant to leave her.
Some months later, when her daughter was four, she
agreed to become editor of *Image* magazine.

On one of her first days as the new editor, she
looked at the mantelpiece in her office. "It was covered
in invitations to dinners, country house weekends, par-
ties, fashion shows and I thought to myself I could have
a great time here or I could do the job properly," she
says. Naturally, being Anne, she did the job with all the
skill, enthusiasm and responsibility she could muster.
Magazines are all about readership, she says, and the
readership results were really very good when she was
there. She was editor of *Image* for just 18 months "and
people still say 'you were editor of Image once, weren't
you?'" she says, in amazement adding, "It was momen-
tous. It was wonderful. It was absolutely the best fun."

While she was editing *Image*, she had continued to
freelance for the *Sunday Independent* newspaper. They
then approached her and asked her to join. She's been
there nearly 24 years, first as Features Editor and cur-
rently as Deputy Editor.

Kevin Kelly was the publisher of *Image* and he did
not want her to leave. "He was very funny. It was like
the father of the bride who's convinced that the daugh-

ter is making a terrible mistake," says Anne. She had to give three months' notice and, as each month passed, Kevin would say, "Anne, it's never too late. You can still say no."

The first thing Anne noticed, and the biggest change that she was conscious of in the *Sunday Independent*, was not having to take responsibility for every single solitary thing herself. She still had overall responsibility, and editorial responsibility, but she was back working with a team of people who were each responsible for different areas like Mary O'Sullivan at "Living" or Brendan O'Connor at *Life* magazine.

Her overall responsibility now is for *Life* magazine and the Living section of the *Sunday Independent*, and for commissioning features for the news section of the newspaper.

"It's complicated because there are different deadlines for all the magazines and the different sections," she says. The Living section is printed on a Friday. The main section of the paper goes right up to the deadline on Saturday night. By Tuesday of any week, the Living section for that Friday's print-run is mostly determined, and there is a fairly detailed outline of the following week's edition. *Life* magazine would be done on Tuesday for the following Sunday week, but the following week's edition would also be planned. "It's all instinct after a while," says Anne.

As you would expect from a woman in her position, Anne has some really valuable nuggets of advice for new entrants.

There were no journalism schools when Anne Harris started writing features. She believes that any education must stand to you, but sometimes new entrants frustrate her. They have gone to media school, know how to present their copy well, and wonder why they haven't become journalists. "The first thing is that you have to want to write. You have to want to tell a story. It's about telling stories. If you can think and tell a story you will be able to write, or you will learn quickly," she says.

Journalism graduates nowadays all want to write opinion pieces. "Everyone has an opinion about everything in Ireland," says Anne "They all want to be Eamon Dunphy or Brendan O'Connor but you have to have a well of inspiration, you have to have lived before you can be having these opinions. I think it's a desire to make a name for themselves quickly when they come out of college. There's a lot of opinion on the net and perhaps they mistakenly think that it's opinion that's wanted – and its not," she adds.

Feature writing is a dying craft, she believes. "It's being killed off by the Internet and by Google and by computers. I always say to young writers coming in who are looking for guidance – if they are willing to listen - if they want to be a feature writer, they have to go out. They have to leave the desk. They have to go to the

scene. If they are going to interview someone, don't do it on the phone. They have to go and meet them. Sit in the chair. Have a cup of tea. You'll notice things about the person. Or if you're writing about something that happened a long time ago, go to wherever it happened, because the stones and the walls will tell you stories. You'll get clues. You'll get insights. It's terribly important because the only thing we have in this world is our own story. And we're a nation of storytellers and that's what newspapers are all about," she says.

Good features should have depth and character and should be more than just style, she says. "The biggest thing that the reader should feel at the end of a good feature article is, 'I want more, that isn't long enough, I haven't had enough here'. If that happens, you have really succeeded as a feature writer. The kiss of death is if somebody sees a feature and says that looks interesting, I'll put that away and I'll read it later. They should see it and want to read it now, and realise its read very quickly and they need more," she says.

She believes that a newspaper "must give people a laugh. That has a very important place in newspapers. A laugh is priceless. Writers like Declan Lynch and Gene Kerrigan can be very funny and Brendan O'Connor can be hilarious," she says. "People aren't going to want to spend €2.50 on a newspaper that is just going to fill them with fear," she adds.

And people do like to feel apoplectic. "It's a favourite emotion actually," she says and then mimics: "Oh my God, it's 12.00 o'clock on Sunday and I haven't felt apoplectic yet. I think I'll read the social diary in the *Sunday Independent* and get annoyed about all those rich people whose lives I don't want to know about but I read every Sunday anyway," she says with a broad smile.

For Anne, there is no such thing as a standard week and there are no regular hours. "You wouldn't be in a job like this if you were going to count hours. Your life and your work become a seamless robe. It's the kind of job that's always with you. If you're out on a Sunday morning walking in a market, you're still thinking about it," she says.

She says that she doesn't subscribe to what she calls the "stress, stress, stress notion" and finds it "very easy to relax. I find it very easy to idle and potter and do nothing. I love my own company. I love sewing and painting and things like that. I'm a sea swimmer, a winter sea swimmer. The thing that I find is the biggest and best unwind of all is a movie," she says.

She is proudest of "having lived well and enjoyed my job and proudest of all of my two daughters".

And the biggest challenge ahead, she says, is deciding on her next career. "I know what I'd love to do, it's not necessarily what I'd be good at, but I would love to be a painter," she says.

Betty Ashe

Betty Ashe was born in the south inner city Dublin where she has lived all her life. A community activist, she has worked tirelessly for the Pearse Street area for over 40 years. She is a founding member of the Westland Row/City Quay social service council and St. Andrew's Resource Centre on Pearse Street. She serves on the council of the Dublin Dockland Development Authority as a community representative.

"I'm not a wife or mother or grandmother. I'm Betty and this is my time."

BETTY ASHE WAS BORN AND REARED, and has lived all of her life, in Pearse Street in Dublin. The street is named after two of the leaders of the 1916 Easter Rising, the brothers Padraig and Willie Pearse who were

born in number 27. It is one of the longest streets in Dublin, and was previously known as Great Brunswick Street.

Betty's father came from north inner city but he "did the good thing and married on the southside," she says. Her mother was from the area. Betty is one of five children. She is the second eldest. She has an older brother, two younger sisters and a "baby" brother.

Both of her parents died young. They were each around 52 years old when they passed away. Her father died of lung cancer, followed, two years later, by her mother who was an epileptic and died of heart failure. Betty's older brother was already based in England when her parents died. Her youngest brother was only eight when their father died and 10 when their mother passed away. Betty was left to care for him. There were 15 years in the difference in their ages.

She looked after her brother for five years until he turned 15 years old. At that stage he moved out to live with her sisters who were closer to him in age. He married when he was just 17. Betty never really remained close to him. "I moved away from the motherhood thing," she told me. "I'm not a wife or mother or grandmother. I'm Betty – it's my time now."

Like a lot of inner city people at that time, Betty never really thought about what she wanted to be when she was growing up. "I didn't have expectations," she says, adding that nobody did.

She was 20 when she got married. "All through the sixties I was barefoot, pregnant and chained to the kitchen sink. And some of the seventies as well," she said.

She gave birth to seven children. She buried three and reared four. "It was rough but when you're young, you take these things in your stride and move on. It wasn't like the present day when you focus on these things," she said. Endurance is her best skill, she adds, saying that she is still living with the same man.

She worked at dressmaking when she left school and continued to do sewing at home, part-time, when she was married. She was always interested in fashion. She loved sewing. She doesn't make clothes any more, but she loves altering things – taking up hems, shortening sleeves, changing the look of something. Doing "knacky" things.

Betty's journey into community activism was a very gradual thing. It almost crept up on her. When her children started school in Baggot Street National School she got involved in doing school trips, and that led to her being invited to join the sewing guild.

At that time, there was a social service sewing guild operating in Baggot Street Covent. When John Charles McQuaid became Archbishop of Dublin in 1940 at the age of 45, he took a keen interest in the plight of the poor of the city, and established a wide range of social services for them. One of them was the Catholic Social

Services Conference (now Crosscare). Formed in 1941, it had a "clothing department", including Betty's guild, which provided clothes for the poor.

Betty was one of the many willing volunteers. There was a sewing machine and overlocker and a table for cutting out patterns in the convent. Betty and a group of local women went there every Thursday. Mothers who had children at Baggot Street School would come in and buy things like pyjamas, underwear and socks at greatly reduced prices. She did that for 18 years.

The sewing guild got Betty involved in working with other women. From there, she began working with the youth groups and got involved as a youth leader.

She was a young mother with young children when she started working with the youth groups. They'd take a group on holidays, including her own two eldest boys. There was a ten-year gap between the older two and the younger two because of the losses in between. The eldest two were brought everywhere, she says. She was involved in running the youth club in Westland Row which Trinity College took over running at a later stage.

Betty might have continued working in this way had it not been for the tragic events in Fenian Street in 1963.

Generations of families lived in the same areas of Pearse Street and the south-inner city and intermarried with each other. Everyone knew their neighbours. There

was a great community spirit. People looked out for each other and shared whatever meagre portions of food they had. The pawnshop did a great business. Inner city Dublin was renowned for its close-knit communities, but there was also great poverty.

Thousands of families lived in the Pearse Street area in dangerously decrepit and overcrowded tenements at the time. Most were crammed into old Georgian buildings and run-down mews cottages in the back alleys. It is estimated that up to 55 people lived in each house, often sharing a single toilet and tap.

In June 1963 there were storm conditions in Dublin city which sent heavy rain and a spring tide. Two four-storey tenements in Fenian Street (just off Pearse Street) collapsed and two young local girls died. They were First Holy Communicants.

Locally elected officials demanded action and there was a public outcry for something to be done. The Minister for Local Government at the time, Neil Blaney TD, ordered an enquiry into the circumstances surrounding the deaths. Suddenly, there was a greater awareness of the dangers of living in these sub-standard conditions. Between June and September 1963, Dublin Corporation served 367 Dangerous Buildings Notices which involved the evacuation of tenants.

The Corporation moved with great speed. "Their demolition squad moved in and demolished all the sub-standard housing and families were scattered every-

where. They went to Ringsend, Donnybrook, Ballyfermot, Crumlin and Drimnagh," said Betty. Whilst Ringsend and Donnybrook were relatively near, Ballyfermot, Crumlin and Drimnagh were, literally, miles away.

Betty's sisters were re-housed in St. Michael's Estate in Inchicore and that was the height of luxury at the time. But the luxury of the facilities didn't have a positive effect on the adults who had to leave the community. "You'd meet them anywhere in town and they'd always have a cry about missing the neighbours and the community, and there was a sense of security and belonging and then to be shifted to a house where you knew nobody and felt very isolated and didn't have the wherewithal to be travelling back into town every day to see their mammy or granny. It was a very difficult time for the adults of the families," said Betty.

It also left the inner city bereft of people. At its height, 22,500 families (very large families) lived in the parish of Westland Row. At a very conservative estimate of four people per family, that was a population of 90,000 people in a single parish. When depopulation was finished, there were less than 6,000 people between the two parishes of St. Andrews and Westland Row.

The only people left in the area were living in corporation flats in Pearse Street, and a high percentage would have been older people dependent on welfare.

The south inner city had lost its mixed community. Betty Ashe and others decided that something had to be done.

At that time, "Sr. Stan was going around the country promoting social service councils for people to set up and look at their local issues," says Betty. Sr. Stanislaus Kennedy, better known as Sr. Stan, has been a member of the Religious Sisters of Charity since 1958. She is a social innovator who was missioned to Kilkenny to work alongside Bishop Peter Birch in the 1960s to help develop Kilkenny Social Services. She spread the vision throughout Ireland.

"She came out to the Pearse Street parish and spoke to us and, as a result of that, Westland Row/City Quay social service council was set up in premises in Westland Row which we got from Trinity College," says Betty. They had no clear vision, no definite understanding of what they were trying to achieve. But they felt strongly that they needed to look at the issues in their area. "We were learning on the hoof. We got funding for a social worker, and a community worker was seconded from the health board to help us look at the issues – and then we really knew we had problems!" she said.

The formation and working of the Social Service Council was a huge learning curve for everyone in-volved. Betty drew on everything she had already learned in life, and proved to be a quick learner of new skills.

Years before, she had worked for an insurance company as a tea lady. "You're the one person that people can come to for a cup of tea and a chat in the canteen. You are a safe pair of ears – but you have to earn the respect and the confidentiality," she says. Being a tea-lady gave her "a lot of experience in mediation and counselling".

There was a real passion among the council members to get things done. To do that, says Betty, they had to learn how to conduct themselves at meetings, how to be constructive and objective, and how to exploit and network any contacts that they made. "If you bring a problem to the table you must bring a solution and then you can have compromise. You can have your expectations, but you have to be able to lower them in a compromising way," says Betty.

"If you're being blocked about a particular issue, you've got to find a way around it. We had to lose that anger and resentment," she added.

The chairman of the social services council has been a source of great inspiration and empowerment to Betty. He's been there for 36 years. "He was an undergraduate in Trinity when he got involved and he's now a top civil servant in the country. When I'd say I need this or that and the chairman (of some committee or local body) won't entertain it he'd say, 'find a way around it'." He taught her to develop her own skills and rely on her own ability to get what she wanted.

In the early years of their development, the council identified the need to bring the community together to be proud of their identity, so they set up the South Dock Festival. It will be 22 years old in 2009 and it has really helped to bring people together, as a community. When it started, Betty and her co-enthusiasts went around all of the small companies in Fitzwilliam Square and Merrion Square and asked them to become a friend of the festival for £25. They wanted to create a large pool of business people who would support what they were doing. They succeeded brilliantly.

Another one of their early successes involved setting up a daycentre for the older people and a laundry service and a hot meal each day. At the same time, the curriculum in schools had changed and parents were looking for help and guidance so that they could help their children. That launched a strong adult education programme.

As the Social Service Council grew and responded to the needs of the residents, they found that there wasn't much scope for many services in the premises they were in.

Because of the depopulation, St Andrews Boys National School on Pearse Street was no longer needed or in use. Designed by William Hague, the school had been built in 1895-97 but had closed in 1976 because of the declining numbers of young people in the area.

The Social Services Council approached the diocese who owned the building and asked if they could lease the premises to develop it as a resource centre. They moved into the building in 1986.

"It was frightening at first because we had no idea how we were going to fill this building. Now space is at a premium. You have to book if you want a meeting and you may not get one!" she says.

One of the earliest adult education learning needs to be identified was the need for Junior Cert and Leaving Cert grinds. As a result, one of the services that emerged was grinds by the Trinity students for the local children. After that, the Social Service Council were instrumental in having the TAP (Trinity Access Programme) set up in Trinity so that if a person came into St. Andrews and studied two subjects for their Leaving Cert, they could go on to the TAP programme and could then access the mainstream degree courses.

This was a huge development for the council because it made university accessible to the more mature residents of the area. The TAP gives people a year to learn how to apply themselves, study and concentrate. No one from the area has ever dropped out of a TAP programme.

The mature students were mainly people who had left school at 14 years of age and were returning to third-level education in their 40s. Many of these mature students are now social workers and teachers or they

are involved in addiction studies. "They in turn are now role models for others in the community," says Betty. "It is now gradually more expected that you will go on to university because your granny done it," she adds.

The fact that they had secured a long lease on the St. Andrew's building also gave them scope for developing new initiatives. Unemployment was a major rot in the community which was affecting the morale and the economy. Betty and her team prioritised addressing unemployment and set up a job centre on a part-time, voluntary basis. They got funding from "People in Need" to do a feasibility study and later on they secured European funding – under the Horizon programme – and Betty took a full-time job running the job centre.

Ironically, the year that there was funding for her to take up a job, she got an award for volunteering. She was now being paid for doing the work that she had previously been doing on a voluntary basis.

There were a lot of redundancies in the area at the time. Traditional sources of employment were changing, downsizing and closing. Places like the Port & Docks, the Irish Glass Bottle Company, the Hammond Lane factory and the Dublin Consumers' Gas Company (or the Gas Company as it was known to all) no longer needed large pools of unskilled labour.

That was the greatest disadvantage that local unemployed people had – they were mostly low or semi-

skilled labourers. The greatest advantage they had was that they had no fear of work. The people of the area had always had a very strong work ethic.

Despite the demise of traditional employment, there was still a large pool of smaller companies in the area. These were the same companies who had developed a relationship with the council through the South Dock Festival. Now, Betty approached them for help with the new job centre.

In the beginning, it was very much a case of cold calling businesses. "But you could talk to a managing director at that time," says Betty. "You could bring a young guy or a young girl along and introduce them and see if they would give them a break. Nowadays, its all HR departments," she adds.

The social services council developed a reputation for being very good at what they did. This, in turn, encouraged local people who were unemployed to come in and register. They had no computers, no resources, no office – there were dividers around a desk in an open plan space. They operated a rolodex and kept box files of local CVs and they were hugely successful. They were placing 280 people a year in the early days.

"It just happened naturally. It had a wave effect on the community. When someone got a job, it encouraged their brother, sister, mother or father to come into us," says Betty.

As the job centre grew, they started looking at FAS employment schemes. There are now five schemes running providing employment for 240 people working in St. Andrews. "Gradually, we realised that we needed a youth service and then childcare. So it became a big family of services. Now, there is not a family in the area that does not link into at least one service in the centre," she added.

However, despite their very best efforts, the area had become deserted and desolate and almost a wasteland. "It wasn't until the Tall Ships came to Dublin that it put a focus on the area," says Betty.

"There was always good cross-party co-operation between our own local politicians – Ruairi Quinn TD (Labour) and Eoin Ryan TD (Fianna Fáil). Ruairi had this vision when he was Minister for Labour in the FF/Labour coalition. He had a vision to regenerate the docklands," she said.

Brendan Howlin TD, who was Minister for the Environment at the time, "gave Ruairi carte blanche. Ruairi set up a working group and they commissioned Sean O Laoire to draw up a plan to regenerate the docklands. He consulted with the communities on both sides of the river and wrote the River-Run report which evolved into the masterplan," she added.

The Dublin Docklands Authority was created, by legislation, in 1997. Betty now serves on its council which is made up of eight local community representa-

tives and five locally elected representatives out of a total of 25 people. The balance comprises public bodies who have a stake in the area.

The transformation of the south inner city area has to be seen to be believed. The "wasteland" became one of the most desirable addresses in Dublin. The area became so trendy that locals could not afford to live there. One of the Dublin Dockland Authority's greatest achievements, Betty believes, was the inclusion of 20 per cent social and affordable housing. They also negotiated a 20 per cent local labour clause but "it didn't work out that well because it was targeted at the construction industry which was never going to be that sustainable," says Betty.

In 1996, an Economic and Social Research Institute (ESRI) study revealed that more than half the population of the Docklands ceased education by the age of 15. When the masterplan for Dublin's Docklands was published in 1997, one of its cornerstones was a commitment to the concept of Saol Scoil – learning for life – and an acknowledgement that education was vital to the sustainability of the area. The Docklands Authority "was very supportive to Joyce O'Connor and the NCI and pushed for it to come into the area," says Betty.

The National College of Ireland was founded in 1951. Originally known as The Catholic Workers College, it had re-branded itself as the National College of Industrial Relations in 1966, and became the National College of

Ireland (NCI) in 1998. Under the direction of Joyce O'Connor, their President, the college embarked on a €25 million fundraising campaign to relocate to a two-acre site in the Dublin Docklands. They relocated to the IFSC Dockland "campus without walls" in 2002. Today, the college caters for 5,000 full and part time students and interacts positively with the local community.

In 2006, the NCI conferred Betty with a fellowship in recognition of the impact that she had on the community as a result of the time and effort she had invested in working for the South-Inner City. In all, six women and seven men were conferred with fellowships.

Quoted in the *Irish Daily Star*, Joyce O'Connor, President of NCI said: "These women have managed, in very difficult circumstances, to see that people have potential and can deliver. Fundamentally, they have created an environment within their community where people can succeed. They have been positive, outward-looking and developmental in an environment which has lots of problems. They have built on the positives within their community."

Betty has written extensively and passionately about her community, how it is moving forward and the issues that need to be addressed. Betty is a great woman for spreading the praise and making sure that you understand that there are plenty of people involved on this journey with her.

Most recently, she contributed an article to a local book called *Seepings from the Margins: Creative Outbursts of Life in the North Wall,* which was edited by Martin Byrne. Her article offers some insights into how much this woman has achieved. In it, she writes: "I am privileged and proud to have played a role and to be part of the team that took up the challenge to bring our area back as a place that is desirable to live and work in." The article continued: "Our greatest strength was that when the tide turned we were open and ready to accept change and embrace it. We have seen the industrial, derelict sites developed into a new quarter of Dublin where residents, workers and visitors can share a place we can all be very proud of."

Betty is also very artistic – as you would suspect from her interest in dressmaking. When she got the chance of a part in a movie she jumped at it. The movie, called *Helen,* was produced by Desperate Optimists Productions. In it, she plays a social worker and is seen sitting at a table conducting an interview. The movie previewed in the Screen Cinema in Pearse Street. She bought 26 tickets because so many people from St. Andrew's wanted to go and see it. It is a "first" for all of the actors involved, none of whom had ever acted before. The film was shown at the Dublin Film Festival in 2009 and it has been entered for a number of awards. Her next movie will be with Richard Gere, says Betty, and she'll use Angelina Jolie as a stand-in for her legs!

When she is relaxing, Betty can be found watching television or with her head stuck in a book – she reads a lot. She's made a lot of friends from the North Inner City, "groups of strong women who are involved over there" and she enjoys meeting them for a meal or a glass of wine. And she loves to travel. She goes to the USA at least once a year (she particularly loves New York, Chicago and Orlando and has been on a few cruises that she enjoyed too!). Turkey and Spain are her other favourites.

She says that she is proudest of "having been given an opportunity to be involved and play a role in getting our community off its knees".

The greatest challenge she faces, she says, "could be the fact that our population is growing. We need integration so that we don't have separate communities. That's what we're doing with the business forum so that they would have as much pride working in our community as we have. And the new dwellers. We need to incorporate them into our daily living so that you're not meeting strangers. Apartment living, in particular, can be very isolating," she says.

Betty Ashe is loving her life right now. She has done everything that was expected of her, and is now concentrating on things that she enjoys doing – working for her community, influencing politicians and authorities, bringing new people into the circle of dwellers where she lives, finding solutions to problems, writing and act-

ing, travelling and inspiring future generations of inner-city dwellers to see themselves and their communities in a positive light. There might never have been a Docklands Development Authority or a regeneration of the inner city without her. This really is "her time".

Caroline Downey

Caroline Downey has been described as the "Queen of Fundraising in Ireland". Married to Denis Desmond of MCD, this former model, who promotes Westlife, Boyzone and Shayne Ward, is the creator and driving force behind the annual Childline concert for the ISPCC.

"The Ann Lovett story made me get involved with children's charity."

CAROLINE DOWNEY WAS GREATLY moved by the story of Ann Lovett, a 15-year-old mother who died, alone, giving birth to her child in a field. She was horrified that this could happen in Ireland in the 1980s and determined that she would make an effort to do whatever she could to help children from then on.

On 31 January 1984, 15-year-old Ann Lovett was found in the grotto by the graveyard on the hill at the top of the town in Granard, Co. Longford. She was semi-conscious and fatally weak from exposure and bleeding. The lifeless body of her six-and-a-half pound newborn baby boy lay nearby. She died shortly afterwards.

Caroline Downey wasn't only moved to tears by this story, she was moved to action. What could she do to help? How could she prevent this ever happening again?

She wanted to do something for Childline. Her friend, Louis Walsh, whom she had known since her teenage years, was managing a band called Boyzone. They would do something he said – and so, the idea for the Childline concert was born.

Caroline Downey had a very exotic childhood. Her family left Ireland for Australia when she was four years old. She is the eldest of three children, her brother was three and her sister two years old when they left. At the time, the Australian Government paid people to move there if you had a particular skill that they wanted and that was what prompted the family move.

She spent four years in Australia, then two years in South Africa, then back to Ireland for six months, followed by a return to Australia and again to South Africa before retuning to Ireland when she was 17 years old.

One of the by-products of all the moves is that she only has two friends from schooldays – both of whom she is still in touch with – Karen in Australia and Leigh in South Africa.

Caroline loved Australia – and still does. She loves their way of life. "I was talking to someone recently about the recession out there – Michael Colgan had a play out there – and he was saying they just get on with it. It's the outdoor life. You don't need a huge amount of money to enjoy yourself in Australia. There's surfing and there's swimming and there's activities all around, so you're not relying solely on the weather. Australians have a tendency to accept you as you are. From a millionaire to a bin man, once you're a cool guy and you're nice and respectable, the people accept you as you are. I think Irish people are very similar to that as well," she says.

She lived in South Africa at the height of apartheid. She returned with her father in 2006 and was astonished by the changes. "It was quite remarkable because when we lived there, there were no black people in hotels or serving behind counters. So it was quite amazing to see the difference – it was 'spot the white man' actually. It was fantastic to see. I mean, it's their country and things are the way they should be," she says.

She was raised in Durban but wouldn't go back there again – too much crime. Durban is the third-largest city in South Africa, has the busiest container

port and boasts a population of 3.5 million people. Caroline's friend Lee is based in Cape Town and she loves that city. It too has a population of 3.5 million, but it is a much more popular tourist destination, and a much safer city.

Growing up she thought she might become an air hostess. Despite all of her travels as a child, or maybe because of it, she wanted to travel more. It never happened. Shortly after the family returned to Ireland, her parents divorced. Caroline was 17 years old. Her mother returned to Australia with her brother and sister, and her father moved to the Middle East. She stayed in Ireland and started working in Captain America's. This American-style hamburger restaurant had opened in 1971. By the 1980s it was one of the trendiest burger bars in Dublin. Located on Grafton Street, it was a popular eating spot for the "in" set

She met her future husband, Denis Desmond, when she was 19 years old. Her friend's husband owned a club beside Windmill Lane and she used to work there, part-time. Everyone who was anyone went there, she says. She met Denis there, and he asked her out for a date. She said she'd go to an afternoon movie with him – but he didn't turn up. "So I went out to dinner and a movie and on to Parkes Night Club in Leeson Street and when I came home at four in the morning, there was a note under the door saying 'I did arrive, admittedly five hours late, but there was a problem on site'."

She was telling the story to her friends in the club the next night and Louis Walsh, a good friend of hers for years, said, "No. No. No. You have to go out on another date because we want to go to Slane and we need to get backstage passes."

At the time, Denis Desmond was working as a civil engineer in England. With his partner Eamon McCann they had found a site and were about to run their first outdoor concert. The gig was the first ever held in the grounds of Slane Castle, Co. Meath. The castle, home of Lord Henry Mount Charles, had never been used as a music venue before. Thin Lizzy were the lead act and U2 were playing support. Hazel O'Connor and Rose Tattoo, an Australian rock and roll band, were also on the bill. The year was 1981.

Louis drove Caroline to the concert, but he really only wanted to see Hazel O'Connor so as soon as her performance was over, he left. Caroline had no way of getting home and no option but to stay for the rest of the concert. "So when Louis claims he set us up, he actually abandoned us," she says laughing. "I was so angry that Denis was so many hours late that he possibly wouldn't have got a second date if it wasn't for Louis so, indirectly, he was a match-maker, but for all the wrong reasons."

Denis gave her a lift home and the rest, as they say, is history. They moved in together three weeks later – in August 1981. Six years later they married. They have

three children – Zack, Jett and Storm – and are still happily together to this day.

Denis formed MCD which is probably the largest concert promoter in Ireland, best known for the Slane, Oxygen, Bud Rising and Heineken Green Energy festivals. While he was doing that, Caroline became a model. When she became pregnant with their first child, she worked as a booker in a model agency. She and her model friends were going to do a run for the Sanctuary Trust, a charity for the homeless. Her friends all completed the run but the pregnancy put a stop to Caroline's participation.

At around the same time, before Zack was born, she learned about Anne Lovett.

"Ann Lovett died giving birth to her child, in a graveyard, at 15 and I couldn't comprehend that nobody knew she was pregnant. I couldn't comprehend that she didn't have anywhere to go to and obviously then, when I had my own child, I couldn't imagine what that must have been like, in the middle of a graveyard, how scary that must have been. And then for her to die later, and the baby to die, must have been just horrendous. And from there on in, I decided to do something about it."

One night at a dinner party she was "banging on about it" and her friend Jane Hogan, who worked with the Irish Society for the Prevention of Cruelty to Children (the ISPCC), suggested that, if she felt that

strongly about it, she should really do something about it. She did.

Caroline had been involved with the ISPCC since 1987. Always an enthusiastic fundraiser, she had been helping to raise funds through the ISPCC Ball, the Brown Thomas Supermodel Show, the Celebrity Football Matches in Tolka Park (Dublin), golf outings, barbecues and barn dances. She had also been part of the board that set up the Childline service.

Childline was now 10 years old and the ISPCC were looking for something "novel" to do for it. It was a good time to introduce a new initiative.

Caroline's friend Louis Walsh was riding high. While working for a record label in Ipswich in the UK, Louis had spotted Johnny Logan and persuaded him to enter the 1980 Irish National Song Contest. Having won that, he went on to win the 25th. Eurovision Song Contest in front of a television audience of 500 million viewers. Louis Walsh, band manager, was born. He had created a new boy band, an Irish version of Take That, called Boyzone – and they were "hot".

Louis offered to help – Boyzone would do something, he said. Denis made his contacts available, they got the Point Depot for free as a venue and decided that the best way to raise enough money out of bands was to make it a concert. RTE then came on board and wanted to film it because they thought it was a great line-up – and that brought Childline to a much wider audience. It

was originally intended as a once-off and Caroline was responsible for putting it together from start to finish.

"Up until then there was almost a stigma about using Childline – people thought you had to be beaten or abused or suffering from something that we adults perceived as a serious problem." The concert changed all that. "The endorsement of the bands telling kids at home, 'this is the number, you should use it, it's there for you', had a greater impact than we ever anticipated," she added. The bands' endorsement brought an acceptance that they would not have believed possible.

Suddenly children began to use the service in large numbers. They began phoning with issues that were important to them. "Some of the phone calls are minor. Like - Can I fall pregnant from kissing someone? Or my brother is bullying me. Or I'm worried about my exams and I've been suicidal," says Caroline. "Childline belongs to the children of Ireland. It is their service. It's for them. They should decide what they want to talk about," she says.

They always bring in more volunteers when the concerts happen because the number of phone calls triples around this time. When the concert is broadcast on television, the number appears on the bottom of the screen throughout. "Its great to see the buy-in from the kids," she says. There are three acts that she can count on each year – Boyzone, Westlife and Shayne Ward. At the 2008 concert, Nicky Byrne of Westlife called out,

"the number is 1800 and "the kids go '666 666'." That number isn't up in the building anywhere. They know it. It's an amazing feeling," says Caroline.

After the success of the first concert, it became an annual event. Caroline still organises it all from start to finish. She can always count on the three "Irish" (she includes Shayne Ward in this group) and works almost a year in advance to put the other bands in place. In 2008 they were given the opening concert to launch the new O2 (formerly the Point Depot). This moved the concert to December, but she thinks she might keep it there. In addition to the Irish bands, the '08 concert was done in conjunction with the X Factor and she'd like to keep that link for future years. She would also have access to American bands who would be touring with singles at that time of the year that she mightn't otherwise get. No one gets paid, she says, and Childline benefits from all the money raised.

In a quirky off-shoot to the concert, which was utterly unforeseen, she began promoting pop bands. She found that she enjoyed it, she was good at it, and has now made a career of it. She works from an office at home, mainly in the evenings, and handles Westlife, Boyzone and Shayne Ward.

In 2007, Childline received 630,000 calls, got 107,000 text messages and had 22,000 messages posted. It the current year, 2009, it will cost €3.8 million to run Childline.

Childline is by far and away her biggest charity commitment, but it is not her only one. Her other big gig is the Meteor Ireland Music Awards. At this ceremony each year a €100,000 Humanitarian Award is made on the night. By 2009, the Meteor Ireland Awards had given €900,000 to charity in this way. Past recipients include Fr. Shay Cullen, Bono, Elton John, Fr. Peter McVerry, Adi Roche and Christina Noble. "Ordinary people do extraordinary things, so you honour them and they get the award, but the €100,000 goes to their charity," she says. Each recipient uses the funds in the way that they think is most appropriate. Elton John put the money into his own foundation while Bono gave half to Unicef and half to Goal.

Caroline is also very clear that she wants her children to be involved in charity work. In 2008, she went to South Africa with the Niall Mellon trust, bringing her son Jett and his friend Killian, who were both in transition year. They were building houses in a township called Khayelitsha.

She remembered the townships of old and, while there is still great poverty, there have been great improvements, she believes. "I remember the townships being really horrendous. I mean, they're still not ideal, but they have roads and running water and electricity. They have improved immensely since Mandela's government came into power. I hadn't expected that. There are now schools and hospitals, and there's a huge infra-

structure in it. However, after six or seven o'clock at night, you don't step outside, it becomes almost a war zone," she says.

In the township that she was in, there were one million people of whom 500,000 were out of work. "There is no dole in South Africa," she says. "There's a 'Catch 22'. You get money if you have children, so the women are having loads of children but they can't afford to really raise children on that money. It's not the solution," she says. "But I do remember that clearly when we were kids – if you didn't work, you didn't eat – and that applied right across the boards whether you were South African, or Afrikaner, Indian or Coloured. They're going to have to address that because, in that sort of society, crime really does pay."

When they were building houses there were shacks on either side. "You could tell who had worked because inside the shack, even though it's a shack, there was a plasma screen and rugs and one woman had a collection of porcelain dogs. The house next door might have had a mother who died of Aids, so the grandmother was raising the small children."

They began working as block layers but Caroline's muscles simply couldn't cope. "I found the physical building quite difficult after the first day lifting blocks for seven hours. We chickened out and went on to painting, and painted twenty-five houses"

Her son, however, stayed with the original project as he wanted to see the building through from start to finish. It was physically very demanding but personally very rewarding. He was proud of himself at the end – and she was proud of him too!

"You feel immense guilt," she says, even though they were doing good. "We were staying in a five-star hotel. The boys (Jett and his friend Killian) were so tired at the end of the day. They didn't know what hit them. They were asleep by eight o'clock. They were only fit for room service. The guys who were bringing us the food were saying what a great thing we were doing, but they lived in Khayelitsha. This (five-star hotel) was what they were leaving to go back to the township and you felt incredibly guilty for what you had," she says.

In an article for the *Sunday Tribune* by Katy McGuinness (who was on the same trip), she wrote about furnishing the finished houses. "I feel like an idiot for asking one man, who earns €10 a week as a gardener and has a family of six to support, what he's going to do about furnishing the new place. He says that he can't even dream of ever having furniture." The poverty is very real.

Caroline believes that all of her children should do something "significant" in their transition year. Her eldest son Zack missed out on his opportunity to be involved in charity work. During his transition year, he was on the senior rugby team for his school. However,

he finished his final year in college this summer and will travel to South Africa with Caroline in November 2009 to build houses for the Niall Mellon Trust.

Caroline had been raising money for the Christina Noble Foundation for years. "Christina Noble is my God. The person who would have a significant impact on me is Christina Noble," she said. Her daughter Storm also adores her, and Christina had visited her school, so they decided to go and see where all the money they had been raising through the Toothfairy Ball was being spent. Caroline runs the Toothfairy Ball with Ali Hewson, Dr. Gary McMahon, dentist John O'Grady, Toni Wall and Dr. David Harris.

Caroline and Storm went to Vietnam to work with the Christina Noble foundation there. The Medical Centre which they visited was so clean that "you could eat off the floor – much cleaner than any hospital you would ever see in Ireland," she says.

In the schools, the children all wear uniforms – Christina insists on it. "She herself having been institutionalised was aware of the stigma between poverty and wealth. She has put about 200,000 children through school. They are all fed in the mornings and you can't tell one from the other, and that's the way she wants it to be," says Caroline.

She was worried about visiting the shelters for boys and girls who had been sold into prostitution. "We saw it when we were there, older American and European

tourists with very young children. It's distressing to watch," she says. At the shelters "there is an off-duty policeman outside their door so that the Mafia cannot come back to take them". She wasn't sure what she was expecting, but what she found were regular children. "They were so happy. They were in a safe house. They went to school every day. They had toys and lovely house mothers who looked after them. It was like a little sorority house. They had bunk beds and stickers of Westlife and Boyzone who are two big bands there."

The place that made the greatest impact on her daughter was the blind school for children suffering the effects of Agent Orange from the Vietnamese War. "The children are born with huge deformities – their eyes are bulging and their foreheads back. They are obviously very tactile. That had a profound effect on Storm because they were all so happy and outgoing and there were no white canes. It was beautiful. They did break-dancing for us, and they sang and they were making jewellery. They were children, just children who were safe and happy," she says.

Caroline takes her charity work very seriously indeed. She is very generous with her time, and, in the past, has raised funds for the Northern Ireland Fund for Reconciliation and 3Ts (a suicide prevention charity). She has also served on the finance board of the Special Olympics World Games.

She supports the charity works of her friends, and they in turn support her – and she is generous with her support. "It works like that in charity," she says. "It's a very small circle, so we help each other out if we can." In the past she has supported Friends for Friends (which helps children of Aids victims), Angels Quest (Deirdre Kelly's charity) and various charities through the annual Ice Ball in the Four Seasons Hotel.

She is also deeply involved in Exploration Station, Ireland's National Centre for Science and Discovery. She first got involved because her friend Ali Hewson asked her if she would join the board of the Children's Museum. She did. Their big concern, and the concern of government, is that children are not studying enough science subjects, so they wanted to create something which would encourage them.

Imaginosity is Ireland's first interactive children's museum for the under 10's based in the Beacon South Quarter in Sandyford, Dublin. Exploration Station will be an interactive science museum for slightly older children.

Caroline thinks that Dublin is probably the only capital city in Europe which does not have a children's science museum – certainly London, Paris, Rome and Amsterdam all have one. Her own three children hated science, but she makes them visit a science museum on every holiday and tell her what they liked or disliked.

"Designing a Formula 1 car and the suit that protects the driver is science," she says, but kids don't see that.

The idea behind the station (first announced in December 2003) is that children will have an interactive opportunity to experience science. The Irish Children's Museum is heavily involved in this project, which is also sponsored by the Office of Public Works and the Department of Enterprise, Trade and Employment.

Along the way, they have had great support from the Departments of Arts, Culture and Tourism who can see the benefit of such a project, and AIB has recently come on board as a key sponsor. They have a site, near Kilmainham, "and the OPW did the most magnificent design for the building," she says. In healthier economic times, the developer, who was to redevelop the area, was to build the museum as part of a deal with OPW. The economic downturn has put paid to that.

Having finally agreed on a site and all of the other elements of the plan, her fear now is that the downturn in the economy will slow the progress of the Exploration Station. Never one to be stopped by mere money, she calmly announces that the downturn "just means that we will need to raise €20 million". When she says it, you do not doubt for a moment that she is capable of raising the money.

She thinks the site is in an ideal location "It's at Heuston Station. Schools could come up by train.

IMMA and Collins Barracks are all close too. So, literally, for their day out, they could visit all three," she says.

"And we could take in transition year students and people studying science. It could be another way for them to get jobs, to work within the centre," she adds.

Although completely driven by her desire to do good, she is also very modest about her achievements. She was awarded the first-ever Volunteer Fundraiser of the Year award in 2008, which she shared with Maureen Forrest of the Hope Foundation. She had gone to the function never expecting that she would win and surprised her entire family when she arrived home with the award.

On the application form, her nominator said, "If there were an Olympics for Volunteer Fundraisers, Caroline Downey would be a gold medallist."

Caroline Downey will continue to work hard for charities in the future, but she believes that the job will be much more challenging in an economic downturn.

She is passionate about the need to listen to children. "It doesn't matter if the problem seems small to us, if they want to pick up the phone and talk about it, it is big to them – and someone should be there to listen," she says.

She if full of admiration for the volunteer counsellors who do such a wonderful job. "I couldn't do it," she says. "I'd want to get into a car and take them all home,

which, of course, you're not allowed to do. The counsellors are remarkable. I'm good at raising money so I'll continue to do that for them and let the people who are good at counselling deal with the children," she adds.

"Irish people are incredibly generous. All charities are going to be needed more than ever. Unfortunately, the corporate sector can't afford to be putting that much money out. Being creative in trying to find new ways to fundraise – that's the challenge ahead," she says.

Little did Ann Lovett know, as she gave birth to her son in that graveyard, that she was also giving birth to a dynamo of charity who will move heaven and earth to fundraise for children's charities so that no child need ever feel alone again.

Christina Noble

Christina Noble was born in the Liberties in Dublin. After the death of her mother she, her brothers and sisters, were sent to industrial schools in Ireland. An unhappy marriage gave her three children of whom she is immensely proud. She *is internationally known for her work in Vietnam and Mongolia through the Christina Noble Children's Foundation.*

"There have been dark times but the good will always come back out with the sun."

IN THE EARLY 1930S, DUBLIN CORPORATION launched a major drive to clear the slum areas of the city. Between 1932 and 1948, the Corporation built over 17,000 dwelling units in inner-city Dublin. They were built in

four locations – Pearse Street, Cuffe Street, James Street and Marrowbone Lane. They were all built as four-story blocks of flats, with communal courtyards which provided access, play areas, clothes lines and storage.

Christina Noble's father and mother had originally lived in the tenements when they were first married. Christina's father was a Dubliner. She says he was a "tall, handsome looking fella at that time". Her mother was originally from Carrick-on-Shannon, in Co. Leitrim. She met Christina's father at a bus stop when she was on her way to college.

Christina was born in 326 Marrowbone Lane flats, off Cork Street, in the heart of the Liberties. It was a one-bedroomed flat on the top floor. Her mother had heart disease and found it very hard to climb the stairs. She kept asking for a flat downstairs. "They gave us one downstairs two weeks after she died," said Christina.

Christina was born in December 1944, six months after the D-Day landings. Her mother went into labour during the Battle of the Bulge, when the Germans attacked the allied forces in the Ardennes in Belgium. The Second World War was nearing its end.

There were eight children in the family. The two eldest children, boys, died shortly after birth. Christina had two older brothers alive, a younger brother Sean, her younger sister Cathy, and the baby of the family, Philomena. The baby was born "just about eighteen

months to two years before mammy died". Christina is the eldest girl and the middle child.

People were very poor in those days but they helped each other and there was a lot of good humour. "The women of the Liberties worked very, very hard. They were the backbone of the Liberties," said Christina. All around "Meath Street, Frances Street, Thomas Street, the Alley, Taylor's Lane, the flats in Robert Street and the Grand Canal you'd see them pushing the old prams and the wheel might be a bit crooked because the laundry was so heavy on it. They'd take it down to the wash-house and do all the washing in Meath Street," she said.

The women were also very enterprising. "They sold apples and oranges, fish, they sold anything they could," said Christina, who can still remember them calling "penny each the whiting, two herrings for a penny". And there was the newly-opened Mulvays shop: "In a way it looked like the beginning of what would have been a cheap supermarket. It was only a big room but they had butter wrapped up on the shelves and all that kind of stuff – loads of it. You've got to remember that, during the war, we had ration books."

Rationing in Ireland was controlled by a similar system of stamps to that of Britain and covered everything including food, clothing, footwear, sweets and chocolate. "Because we had TB, tuberculosis, my brother Sean and I were allowed six eggs a week and milk – I think

something like six pints of milk a week – something like that," she said.

Christina remembers times being really hard when both her parents were alive. Women weren't allowed in the bars, so there were little snugs in the pubs. They would go into the little snug and "they used to have a bottle of stout and you'd hear them all talking about their loved ones who went to England. The women would be broken hearted and singing," she says. A lot of people at the time took the cattle boats to England and never came back.

"I wish there was a snug like that today for women, to go and have a chat, because they were just fantastic," she says. "The Liberties had got its good points, and it had got its bad points, like all over Dublin. I tell you what was in the Liberties – there was a big soul and a big womb and an incredible heart," she says.

Christina grew up wanting to be an entertainer. She remembers all of the popular songs of the time. Count John McCormack was very popular. McCormack was made a Papal Count by Pope Pius XI in 1928. Internationally acclaimed, he was, perhaps, the most famous Irish tenor of his day. Dean Martin's "It Takes So Long to Say Goodbye" and "Daisy Bell", popularly known as "A Bicycle Made for Two", were other favourites. When the film *The Student Prince* was released in 1954, all of the Mario Lanza songs were very popular. The other song Christina remembers is "I'll Take You Home Again

Kathleen" which is generally thought to be a famous
Irish ballad. In fact, it was written by Thomas P.
Westendorf of Indiana, in 1875, for his wife (whose
name was actually Jennie).

Christina vividly describes the food and the generos-
ity of people in sharing what little they had. "One night
a week, you know, they'd bring back a few bottles of
stout in a paper bag and the wife would be at home, she
might have already cooked the pigs cheek and it would
be lying in the pot of jelly. Then they'd get two or three
turnovers and maybe a half-pound of butter or maybe
mix it with the margarine. And they'd cut the bread and
maybe put the jelly on as well. People would even suck
the ear of the pigs head," she said. "And sometimes
they'd boil a whole pot of eye bones and neck bones and
people would eat that. It was lovely – I used to eat that
as well. There wasn't a lot of meat on it though," she
adds.

Mutton stew and coddle were also very popular at
the time. "In the coddle they put the sausages, the rash-
ers – the rashers would have loads of fat on them be-
cause they'd get the cheap end of the rasher and the lap,
with a string of what appeared to be meat on it and
when you boiled all that the fat used to be floating on
the top," she says.

"If they got a lump of corned beef, they'd boil the
cabbage in that with a half teaspoon of bicarbonate of
soda so that it wouldn't taste like leather. That meat

would be for the dinner that day, and the tea, and the dinner the next day, and they might put it in a sandwich, and they might even try and stretch it for another day. And they used to fry what was left of the cabbage and potatoes and two big thick cuts of bread and everybody would be fighting for the heel," she says.

Deserts were a rare luxury. "On a Sunday, I remember a few times we had custard and jelly and we used to get tapioca and stuff like that, because the tapioca would fatten you up, you see," she says. Semolina and macaroni were also popular. "Everything was to keep you a bit fat to help you fight disease. There were a lot of bad diseases around at the time like diphtheria and tuberculosis. They used to call that rapid consumption. People would say, 'see that man? He has rapid consumption'. They didn't like to use the actual word," she says. Tuberculosis was rampant in Ireland in the 1940s and 1950s. Consumption was a good name for the disease because the victims were "consumed" by weight loss and breathlessness.

"You'd see groups and groups and groups of people and they'd be all getting ready to walk up to the deadhouse. There was one up in the Union, St Kevin's Hospital, now it's called St. James." The building was originally used as a workhouse in the late nineteenth century when it was known as the South Dublin Union. "At that time it was called the Union because it was the pauper's

hospital. Paupers – I hate that word. My mam was buried in a pauper's grave," she says.

She was 10 when her mother died. "My development was stunted when mammy died and the trauma that went with that and no one to talk to. You just couldn't cry. You had to get on with it, I had to look after the rest of the family and I was going through a lot myself. I was at puberty age, almost, by that stage. I didn't know what that meant," she says.

Her father was an alcoholic and couldn't look after the children when her mother died, so the family were divided into different industrial schools. Christina was sent to the Clifden orphanage in Galway where she stayed for six years. She suffered horrific abuse there.

But she also "had an incredibly creative and imaginary, wonderful life. Christina created this beautiful yellow and golds and reds and blues and she sang and she danced through them and that's what mammy would have wanted me to do," she said.

She also tried to make the best of her surroundings. "Even in the institution, I made fun. I worked hard. And there were good sisters and one or two not great. It was tough and it was hard, don't get me wrong. God, sometimes I was afraid. I was so scared." But she used to sing, songs like "Far Across the Deep Blue Water" and Bill Haley's "Rock Around the Clock" and, of course, she'd get into trouble: "I'd get all the kids going and I used to get into trouble for not studying but the kids

loved it and when I was leaving they were crying because they said, 'we're going to miss you, we love you'."

She was told that all of her brothers and sisters were dead. She believed that she was alone in the world.

When she was 16, they handed her a five-pound note and sent her back to her father in Dublin. She found her father in the same state she left him in, drunk and destitute. Not long after they were reunited, he took her money to buy bus tickets so they could get away from Dublin. The last time Christina saw her father, he was heading into the local pub to get change.

Christina ended up living on the streets of Dublin. She was raped and became pregnant and gave birth to a son – Thomas – he was with her until he was about three months old "or maybe a little bit older".

"First there was confusion," she says. "I didn't understand about pregnancies. I thought Dr. Finnegan brought the children in a bag. I was in an institution, a convent, an industrial school. We never learned anything in Marrowbone Lane. It was all hidden from us, that stuff. It was all Dr. Finnegan, or the cauliflower or the cabbage. And that was the nature of the times and it was normal and I'm not saying there's even anything too bad about that at all."

Christina moved to Birmingham in England, got married, and has three children with the most amazing names – Helenita, Nicolas and Andrula. She's very close to the children and incredibly proud of them.

Andrula is a psychotherapist and psychologist. "She's also a writer and in America, somewhere around Los Angeles, one of the top universities out there, they hailed her as a Sylvia Plath. She's a brilliant poet. The professor at the University of London said that she will be, if she wants to be, one of the new great writers of our time. She won a big award in Bangor, at the University of Wales, the literary award, Prince Charles was giving it," she says.

Andrula also has "a first class honours in social science and first class honours in literature and English. And she's studied African studies and women as well. She's also doing therapy for the students at the University of Brighton and she also does psychotherapy and psychology for the children in the clinic – you know the kids from the inner city who get into real trouble, the toughest of the toughest, she's the psychologist there in London."

Nicolas has a degree in business studies and management. "They said he should have been a barrister or a lawyer because he was so brilliant as a student in law," says Christina. "Nicu is just very smart in every direction. He's very creative and he has a business mind. He's sharp. He's been offered huge amounts of money to be a consultant in the business field in Asia and he declined because of the foundation," she says. "He writes as well. He loves poetry and he paints. My brother Michael was a great painter. I paint also," she

adds. Nicolas works for the Christina Noble Foundation in Vietnam.

Helenita appeared on BBC television as one of the Krankies. "It was a very famous comedy for children. She was the woman with short hair who used to wear little trousers and a cap," says Christina. "She was on 'Bacon and Eggs' on a Saturday as well." Christina describes her as "a mid-Atlantic rock singer". Helenita set up her own group and has two or three golden discs. She also was with Chappell Warner as a writer and she also wrote with Simon Burton. "She stopped at an incredible time. Her records were in the charts in Germany and America. And Bryan Adams wrote a beautiful song for her, she did a concert with him and everything," says Christina. Helenita currently does all the public relations for the Christina Noble Foundation from her base in Britain.

Christina also dotes on her grandchildren. The eldest is "Thomas, then Georgie, then Sava (after his grandfather), Nicolas and Elenny (named after Christina's great, great aunt). And, any more grandchildren, I just hope they call them Michael and Joseph," she says with a laugh.

Christina started her work in Vietnam in 1989. She had a dream and in the dream a voice told her to go to Vietnam – she had no idea where Vietnam was, but she was determined to go there and help the children. She arrived in Ho Chi Minh City (formerly Saigon) with no

credentials, no contacts and no money – just a determination to help children. Less than two years later she had built the Children's Medical and Social Centre in the city. She now has 101 projects running in Vietnam including Sunshine Schools all over the country.

She started working with the children of Mongolia in 1997 and now has 12 or 14 projects running there, including one in the Gobi desert. She does most of her work with the street children in Mongolia's capital, Ulaanbaatar.

"Let me give you an example of what we do," says Christina. She tells the story of a little girl in Mongolia who lost her mother at a very young age. Her father went off with another woman. The child "was thrown out on the streets and she was raped and abused and used over and over and over and over again – like a trafficked child. She had disease after disease. The kid was at the end of her rope. But she didn't give up. She heard about us in Ulaanbaatar. We took her in, we held her, loved her, bathed her, dressed her – and she's now at the University of Ulaanbaatar and she's studying to be a social worker and then, once she's finished there, she'll go and take her masters, in London or somewhere. She's a brilliant student," says Christina.

"And we have the bakery at the children's prison because we've changed all the stuff at the prison," she says. "We put the bakery in for the kids to bake bread for themselves, for them to learn the skill of becoming

bakers. We put full time education in there. I'm talking about prison, real prison, with hard, tough wardens. We put schools in there and we put all our own teachers in there. We also have information technology, computer technology, as well as academics. They also learn how to plant seeds and make things grow in a very difficult, cold climate and the best thing as well is that the wardens, who would beat the kids up, and put a gun on them – well, not all of them would put a gun on them – but it was said that a song they had to sing was because their friend was shot in the back by a warden, a drunken warden. That doesn't happen now. I'm not saying that was all over the place, that was an exception," she says.

"But what was not an exception was the battering and the beatings and the horrific things that happened," says Christina. "These were children who stole a loaf of bread, or an apple, not because they wanted to be a thief, but because they were starving. And sometimes they stole it to bring back to their mothers. It's one of the poorest countries in the world and its getting worse, it's not getting any better, because all the animals are dying down in the Gobi Desert. The Gobi people are all coming into the city. There's nothing in the city. We run a massive programme out there. If it wasn't for us, there would be thousand and thousands already dead. And that's well known – we're highly respected for our work," she adds.

"You know, we work down the holes, down the manholes, we bring the kids up," she says. The man-

holes under the ground contain the heating system for the city. In Ulaanbaatar the temperature in winter can be minus 30 degrees. Street children live below ground to try to stay warm.

"We have the hospital programmes as well. We built the whole paediatric unit of the Mercy Hospital," she says, and "we have another big clinic at the Mother and Children's Hospital."

The foundation needs something in the region of €1.5 million for the two countries each year. "It's top value. Everybody says, how the hell do you do it?" says Christina.

"I had a donor in England. He's a businessman but he's a hardworking businessman from Kerry. He was supporting us and I said to him one day, 'are you ever going to go out and see?' He said, 'I will go when the time is right'. And he did. He went out and he came back and said, 'I knew I'd find some very good things but I've never seen children so happy, just really naturally happy,' he said."

Christina has been recognised by the President of Vietnam, she holds honorary citizenship of Mongolia, the Queen of England has given her an OBE, and she has received numerous honorary doctorates and awards. What do they mean to her? "When they do those things, the awards and things, I say, 'oh God, what would my mum say? My mother would say, 'oh, look at her, and she was like a little tomboy'. And my

dad would have said, 'ah, I always told you Annie she was different'. He used to say that – Ina's different, I don't know why, but she is."

She keeps in touch with her brothers and sisters, and loves them deeply, but says that the whole family has great difficulty displaying emotion. "I say to them, 'I love you'. I always say to them, 'I love you', but there's a look in their eyes, the head goes back, they're not comfortable with it. For many, many years I've always said, when I saw them, 'I love you'. And then, my brother (Michael) told me he loved me two weeks before he died. He rang me and he said, 'I just wanted to tell you I love you', and I said, 'and you know that I love you too?' and he said, 'yea, I know that'."

"I told my sister Philomena, 'do you not understand how much we love each other?' but she can't go there at all. Cathy can't go there. The word 'love' is very hard. There's love but it can never be spoken about. The past can never be spoken about. It's too painful." Her brother Sean told her, "they'll never know what they did to the whole family. They'll never know," and he broke down crying and walked away.

"He's in Texas now," says Christina. "He was in Switzerland. He's 62 and he started counselling just about two years ago. He's very intelligent. He's a very well educated man, a research chemist for Ciba Geigy, but he would only research the plants because he can't hurt anything, like all of us. We can't even kill mosqui-

toes. We just can't cause any pain to anything, even for a moment, even though we know it carries disease. We are all very aware of the suffering of others and the pain of others. We can sense it," she says.

Christina has written two books about her life. *Bridge Across My Sorrows* (with Robert Coram, 1994), and *Mama Tina* (with Gretta Curran Brown, 1998). "I remember both brothers saying to me at different times, and both sisters at different times, they said, 'You know your book? If they only knew the real reality', and I said, 'But, you know, if you put everything in, then people are not going to be able to read it because it will be too heavy for them, it will be too hard for them, and it may cause them pain too'," she says. "What you want them to do is understand, not put the book away and stop reading," she adds.

Christina was raised a catholic and has great personal devotion and faith. "I want to make this very clear. I don't blame the church for what's happened in our life. You know, it was great to be able to go and sing in the church. You felt you belonged, you could talk to Our Lord and you could tell Our Lord all your worries. Everybody needs to have some loving soul to talk to and some spiritual feeling," she says.

"And that doesn't mean that I deny what happened to my brother who nearly died in the hospital in Galway because of Letterfrack. My brother was there six months, and he just survived. They told him they were

going to put him in grave number thirteen. He was beaten so badly and he was left out in the cold, in the yard, he got double-pneumonia. My brother had a terrible life, a shocking life. I had a hard life in there and my sisters had a very hard life in their place. But I also remember the sister who used to come to our house when mammy was sick – from Ballyfermot, from the Little Sisters of the Poor, she was a saint. I also remember Sr. Anne down in Galway, in Clifden where I was, she was pretending to be tough but she was actually very soft really. She didn't really want to destroy us," she says.

She has had some serious health problems over the years, and relaxes by indulging her creative side. "I love poetry, I love painting, I love colour – I'm a nutcase for colour, everybody knows that. And I love talking and I walk a bit. Because I have legs problems and all kinds of serious stuff – and you know I had the old cancer stuff and the double bypasses and the super-ventrical-taga-cardia – it's like a song isn't it? – you just carry on and just carry on. And accept the days that your body is saying, 'hey, come on, sit down and watch a film and it's OK to watch a film, don't feel guilty about it, watch a true love story'." And she does.

The greatest challenge she faces is "to get the world to listen, to hear, to get the leaders to hear," she says. "There have been dark days and dark times but that's all over and the good will always come back out with the sun again."

Danuta Gray

Danuta Gray was born in Sheffield in England. She worked in Germany, Singapore, the UK and the USA before taking up her current position as CEO of O2 in 2000. A science graduate, she is also a board member of Irish *Life and Permanent and Aer Lingus. She lives in Enniskerry with her husband Andrew and their two young sons.*

"Why be an academic? The sales and marketing people drove the flash cars."

DANUTA GRAY WAS BORN IN SHEFFIELD in the north of England, not all that far from Manchester. Her mother was English and her father was Polish.

The Second World War began with the invasion of Poland, by Germany, in 1939. At the start of the war the

Nazis came into her father's village at about 10.00 o'clock one night. They demanded that, within half-an-hour, the young men and some of the young women from the households pack a bag and be ready to leave. Her father was 13 years old. He was taken away and never saw his parents again. In fact, it would be 30 years later, in 1969, before he was reunited with some of his brothers and sisters for the first time.

Her father had fought with the British Armed Forces in the Second World War. He was 19 years old when the war finished. Like a lot of Poles, he found himself in the UK and couldn't get back home at the end of the war. Poland was still occupied by the Soviet Union and under communist rule, so he remained in England as a political refugee.

The post-war Polish communities in England were formed of Polish ex-servicemen and women and their families, who had fought under British command during the Second World War. The majority had been deported from Poland for political reasons. There were strong Polish communities in Glasgow, Manchester, Birmingham, Leeds, Bristol, Sheffield and Nottingham. The largest concentration of Poles was in London.

These were mainly Catholic communities with their own churches, social clubs and Saturday schools. To this day, there are still strong Polish Ex-Service Men's Associations, Ex-Combatant's Associations and Polish Catholic Clubs in some of these cities. Many of the Pol-

ish communities have grown in size with the influx of new migrants since the accession of Poland to the European Union.

Her father started working in Scotland as a miner. It was hard, physical work and quite dangerous. Between 1945 and 1949 there were 173 mining deaths in Scotland. The youngest was a 14-year-old pithead worker who died in the Polkemmet Colliery in 1945. The oldest was an underground colliery fireman who died in Cowdenbeath aged 71 years.

From Scotland, Danuta's father worked his way down the country ending up in Sheffield where he worked in the steelworks. Danuta doesn't remember him working there, but she does remember his next job – working as a milkman. She remembers him getting up at 3.00 or 4.00 am and taking out the milk cart. Later, when she was six or seven years old, he opened a shop and ran a delicatessen.

Her father was a very intelligent man who never had the chance to have any formal education. Like most other ex-combatants, he never spoke of his experiences during the war.

Danuta's mother was English. She was born in Aldershot in the south of England where there was a large British Army presence. Her father was in the British Army so she had moved around a lot as a child (as is normal for army families).

She spent her younger years in Darlington in the northeast of England. She studied in Edinburgh and qualified as a speech therapist. She worked with the health service helping children who couldn't speak and older people who were recovering from strokes. It was her career that took her to Sheffield where she met Danuta's father.

There was a social club in Sheffield, a Polish club, where Poles would meet and reminisce about the mother country. They also held dances and it was at one of these that her parents met. They were married about a year later.

They lived in the heart of the Polish community in the town, where Danuta and her brother grew up. The entire family spoke Polish when they were small, but her father was worried that they wouldn't have good enough English so, from the time they started going to school, they spoke English at home. Although she grew up bilingual, she can only understand a bit now and say things like "thank you" and "good morning". Her mother is still a fluent speaker.

Her father was keen for his children to get a good education. "He really believed, like a lot of emigrants, in the power of education to help you get on in life," said Danuta. He was a huge force in encouraging herself and her brother to study hard. He also instilled in them an acceptance of people; he couldn't tolerate any form of prejudice or racism – and neither can Danuta.

Danuta is the eldest in the family. Her brother is slightly younger than her. She says that they were a very ordinary family, living in an ordinary city. Sheffield is not wealthy, and most businesses seem to revolve around the steelworks, cutlery and manufacturing. But it is quite a compact city, and the people are very friendly. She still notices this when she goes back to meet her mum.

Danuta first went to St Wilfred's primary school and then spent a couple of years at secondary school before she won a scholarship to go to Notre Dame Grammar School for Girls. "They had a sign – Notre Dame High School for Young Ladies – when I enrolled. About a year after I arrived they took down the 'for young ladies' part. I'm not sure if there was a connection," she says laughing heartily.

By her own admission, Danuta was terrible at sports but she was good academically in school. "I found all subjects relatively easy. I enjoyed studying. I have always enjoyed learning. When it came to things like exams, I was one of those lucky people that could read something, remember it, put it down in the exam and walk away. It was a talent I didn't realise I had at the time and I didn't appreciate it enough," she says.

Danuta ended up doing sciences. "My more natural inclination was maths, science, physics, biology – that type of stuff. In the UK we do A-Levels which is slightly more restricted than the Leaving Cert here. You typi-

cally do three or four of those, rather than the range of topics we do in Ireland," she added. There is no science in her family background. Her uncle, one of her father's brothers, was talented at maths and her grandfather, her mother's father, was also a good mathematician. So there is mathematical ability on both sides of the family, "but there were no Nobel Prize winners or scientists in the background that we've ever found," she says.

Danuta was shy as a child, but that all changed when she reached 15 years of age and she "came out of herself". Her newfound confidence coincided with a visit to the school by a theatre group, who were looking for six girls to go on tour with them, performing in *The Prime of Miss Jean Brodie*. The movie had been a huge success in 1969, winning Maggie Smith, who played Miss Brodie, a coveted Oscar for Best Actress. The play told the story of Miss Brody, a schoolteacher, who dismisses the standard curriculum in favour of lessons covering subjects which include her own romances. Her pupils, the Brodie set, are besotted by her.

Danuta was one of the six chosen. To this day, she can't really remember how the six were chosen, but they were allowed out of school to "perform" in local rep theatres in and around Sheffield in the evenings, and she had a ball.

When she was 17 years old, she discovered boys. They proved to be a distraction to her studies so, while she got good marks in her exams, she did not get the

straight A's that would have been expected of her. This meant that she could not become a doctor. Her father was devastated and wanted her to repeat her exams. His dream for her was shattered.

Her mother was relieved. She had previously made Danuta work in some hospitals to gain experience and she knew that her daughter was not suited to a life in medicine.

Instead of repeating her exams, she went off to Leeds University to study physics. "It was probably the best thing that ever happened to me," she says, adding that "physics is the science of what makes the world tick".

Leeds University is about 50 miles from Sheffield. It is among the top ten research universities in the UK and is known for its leadership in the field of physics. In 2009 the *Guardian* and *Times* newspaper league tables both put Leeds University in the top five university physics departments in the country. The university has in excess of 250,000 graduates across all disciplines.

When she graduated, Danuta worked for a while in the research department of a pharmaceutical company. She quickly figured out that being an academic just wouldn't suit her personality. "You could see the difference between being in sales and marketing and being in the laboratory. The people who worked in the laboratory, where all the drugs were designed, didn't drive the flash cars or seem to have as much fun, it appeared to

me, as the guys who were in sales and marketing," she said.

She left the pharmaceutical company and joined BT in the mid-1980s. Information Technology (IT) and Communications were really growing at a rapid rate then. British Telecom was originally formed in the late 1970s to give a separate identity to the telecoms arm of the English Post Office. In 1981 it became a distinct public corporation in its own right. In 1984, it was privatised, launched on the stock market, and separated out as a new company. It was around this time that Danuta joined.

BT is now one of the world's largest communications companies operating in over 170 countries and managing 21 million customers. It has a staff of over 100,000 people and annual revenues in the region of £22 billion.

Initially, Danuta worked in the IT department but she moved around quite a bit. She was originally based in Leeds, but also spent time in Manchester, Birmingham and London. She also got the chance to work in Singapore and the USA.

Singapore is at the southern tip of Malaysia in the Far East. It began life as a trading post for the East India Company and developed a reputation as a thriving port, which it still is. Most of Singapore looks as though it has been built in the last 25 years. It is very different from its near neighbours, Thailand, Cambodia and Indonesia.

Danuta thoroughly enjoyed working in Singapore but felt that it wasn't somewhere she would like to settle. "It was fascinating to work, even for a short period, in a different culture but it is very clean and orderly and I would prefer something a bit more chaotic. So, in the Far East I would be more of a Hong Kong person than Singapore," she says.

Washington wasn't as she imagined it, but she really liked it a lot. "It was interesting in terms of working with the Americans. I had a view that they worked incredibly long hours and never had holidays, and it wasn't quite like that. They actually have a great balance in terms of working life. They're very gung ho and full of energy. Lots of 'can-do'. It was fun to work there," she says.

After that she worked in Switzerland for a while but never settled there. Instead she commuted back and forth. But when she was sent to Germany, her family relocated with her to Munich. They were there for about three years.

They moved when her youngest son was nine months old and her eldest boy was three years. Her job involved looking after a German business that BT had a stake in. She loved Munich.

Munich is the capital city of Bavaria in Germany. It is the third largest German city after Berlin and Hamburg, with a population of approximately 1.4 million people. The family had a great quality of life when they

lived there. "It's a very outdoor lifestyle," says Danuta. "Long hot summers and cold, crisp winters. It's great from a young family's point of view."

However, her experience as a woman in business was something that Germans were neither familiar nor comfortable with.

Her husband had given up his job in order to help them move around. Until their second child was born, he had been in business in a partnership with someone else. However, with two young boys they had jointly taken the decision that he would stay at home with them. They had home help and he was perfectly happy to support Danuta in her career.

The neighbours in Munich, however, were completely confused. "I was the one getting into the car, going to work every morning, and he was the one on the doorstep. I could see that they thought that this was not natural, not right, not normal, shouldn't be happening," she said. She asked her secretary about finding the name of an agency to get a nanny, someone to help in the house with the children. The secretary was genuinely taken aback. "No, she said, we don't have that here. Either you would stay at home to mind the children or you would get your mother or grandmother to help," she told Danuta. Now she could understand why the neighbours reacted so strangely to her husband. She had imagined that her cultural experience would trans-

late to Germany. It did not. Her family's lifestyle was a source of great confusion to the Germans.

She first met her husband Andrew when she was still at school. "I used to go to Mass on a Sunday evening. There was a gang of us, because that allowed us to get out of the house with a good reason to tell our parents. We used to tell them that there was a Youth Club after mass, which there was, but which we didn't actually go to," she says. Instead they used to go to a local pub. Her husband would be there playing darts. Both Danuta and her friend took a fancy to him so there was a bit of a competition to see who could get him. "So I won, which was good," she says, adding "obviously, at the time, you didn't think you were still going to be with him at this stage".

They didn't get married until 1993. Until then, they had been "living in sin" or "living over the brush" as it was known locally, "pronounced 'living overt brush'," says Danuta. The phrase "living over the brush" is a Yorkshire one, which comes from the days of tunnel building in the nineteenth century. At that time, if a boy and girl took a liking to each other, but could not afford a church wedding, they would hold hands and jump over a brush or broom handle held by two older people. They were then "married" in the eyes of their peers.

They married in 1993 and had their children quite soon afterwards in 1996 and 1998. Danuta was around 35 having her first child. "It was all very logical," she

says. "From the age of sixteen, even though I didn't know what I was going to do as a career, I always said that I would never have my first child till I was at least thirty-five. I always wanted to travel and have a career and get to a point where I thought I would feel comfortable taking some time out to start a family. Now, it just happened to work for me, but I think that's kind of special. I was kind of lackadaisical about it," she says. "I just assumed that it would happen and it happened almost to the day."

But, when it happened, she didn't take the time out. She is not a woman who regrets things generally, but she has two: "One is not knowing my dad better before he died, and I didn't take time out when our eldest Max was born. I took about eleven weeks off. It was a very short space of time and I'd had a caesarean. I took a little more time when Hugo was born, about five or six months off, but still not much more time," she says.

She is very conscious of equality. It is as much her husband's choice to stay at home as it is hers to work. But she is also very conscious of her independence. "I was brought up that way. My mum worked from the time I was four or five years old. She worked full-time which was slightly unusual at the time. Both mum and dad brought us up to believe that men and women are equal. Mum was always very keen on us being independent, particularly as a woman," says Danuta.

She knows that she is incredibly lucky to have the equivalent of a wife at home. "I don't think I could have done the job in Germany or here without that support," she says.

Meanwhile, Digifone in Ireland had been bought by BT and they were going to float all of the mobile phones off, away from BT on to the stock market. Danuta was interested in moving from the back office job in Germany back into the front line. She was keen to re-engage with sales, marketing and customer service. She gets a buzz out of working with a team. When the job came up, she went through the selection process and got it. The family were on the move again.

She had been in Ireland only once before – for the interview. Now, on her second trip, Andrew and the boys travelled with her to look for a house and a school.

She might not have been in Ireland regularly, but she had an understanding of what the Irish were like. "I was brought up with a lot of Irish kids at school. I was always jealous of the Irish sense of identity and jealous of them having the shamrock. There was a feeling that they really know who they are," she says. Because her school was a Catholic school, the more predominant cultures were Irish, Italian and Polish. She had a sense of knowing Irish people. She had an Irish auntie – not a real one – in Cork and she always had a sense of some connection. "From the outside my view was also coloured by the Celtic Tiger phenomenon. So I had a view

that it was a young economy, growing rapidly. The workforce in Digifone were the epitome of bright, young, go-getting Irish types, or Irish who had come back from overseas to come home and work, which had not been an option when they left college. There was a real buzz and energy about the place that was very appealing," she says.

Being CEO of Digifone really felt like being thrown in at the deep end. "It was probably far too soon for me to take on that role. First of all, you're following on from Barry Moloney, a strong guy, who took the company from nothing and built it up and was moving on. Then I was also an English person arriving in Ireland, and while I'm from the north of England and there are connections and similarities, there are still phrases and words that were unknown to me or had different meanings. Then there was just the breadth of the job. Then we were launching onto the stock market. It's a lot to get your head around in the first couple of years," she says, neglecting to add that she did it all with what appeared to be great ease and enthusiasm.

Digifone became O2, and O2 is now part of Irish life, and Ireland is home. "When we first arrived, we went to Eddie Rockets. We were sitting on stools, at a bar, with the two little fellas, having our burgers. We were only here a week and the oldest guy, who was about five and a half years old says, 'I love it here mam and I never want to leave'." He had just fallen in love with the coun-

try. They all had. The family now lives in Enniskerry and are part of the community there – particularly her husband.

For a woman who says that she doesn't get the "work–life balance" thing right, she makes a pretty good job of it. "You can't do a job as CEO on a nine to five basis," she says. "There are lots of things you have to be involved in. The role is pretty full on."

But she tries to keep the week for work, and weekends for the family, and succeeds "about nine times out of ten. I go home in time for tea on Friday. We always try to have tea out as a family together, maybe in the pub, and it marks the start of the weekend," she says. They all do different things at the weekend. Her eldest son might be going to golf lessons and her younger son might have friends in. "At the weekend, I'm mum," she says.

Until recently, she wouldn't have been comfortable with mentoring women particularly. What she would have done was encourage talented young people, male and female. However, in recent years, she has done some things where she has actively mentored young women, where they've asked her to. She hadn't realised that, for them, seeing a woman in a CEO role is more significant than it is for her. They want to overcome barriers that they see are there, but that she may not have identified or perceived at all because of the support she has had from bosses in the past. Latterly she

thinks, "if that's what young women want me to do to support them, then that's OK".

She doesn't read biographies of great achievers. Instead, she is inspired by "ordinary" people (although she hates that term). Perhaps people who are not in the public eye might be a better description.

She mentions two people in particular – both women. Sr. Antoinette works in Glasnevin and has given support to Danuta's eldest boy over the years. Sr. Antoinette helped to create a school, St Johns in Glasnevin, and she has done it "through begging and borrowing and forcefully persuading people to give their time and money," she says. The school is for children who, for example, are coping with dyslexia. Sr. Antoinette takes them out of the mainstream, gives them one on one help, then they go back into mainstream education. "People with a passionate belief in what they are doing are the people who inspire me," says Danuta.

She also singles out Caroline Casey, the woman who created the Aisling Foundation, now known as Kanchi, in 2000. Caroline, a visually impaired social entrepreneur, formed the association because she cares deeply about improving people's perceptions about disabilities. In association with Kanchi, Danuta's company sponsor the O2 Ability Awards annually.

Danuta is a great woman for walking. At lunchtime she likes nothing better than to take off for a long stride around. "I like going on my own to clear my head and

listen to the trees and birds," she says. She also goes swimming a couple of times a week. She likes the repetition and motion – it frees her mind to think more clearly. She has tried meditation in the past, she says, "but I find it difficult to sit still and do nothing". She loves reading on holidays and positively "ploughs through books" when she is away.

Holidays, as one would suspect, are family affairs. They all love to go skiing as a family twice a year. And they always try to do a big trip. "We go to this brilliant place in Canada where we go salmon fishing. We put all the fish back." Eagles flying around and a cabin in the wilderness – it sounds heavenly.

Looking back, she is proudest of her achievements with O2 in Ireland. The company is seen as part of the fabric of Irish society, and that is important to her. There is also the O2 concert venue (previously the Point Depot) of which she is very proud. And there are the O2 Ability Awards and the work that they have done with Irish Autism. And, of course, there is winning in business and their achievements in the marketplace.

The biggest challenge of the future, she believes, "will be always making sure that you are changing, as a person and as a business, to be ready for the future. In business, you can never rest on your laurels. Where is the new growth coming from? How do I make sure that we keep asking ourselves are we doing the right things? Have we changed enough?"

Danuta Gray thrives on the challenge of business. She gives it her all and clearly loves what she is doing. She has an incredible support system in Andrew, who makes it possible for her to do what she does without the usual domestic worries interfering. She is settled and happy in Ireland, and part of the fabric of the country. She is an honorary Irishwoman. I have no doubt, though, that when the next challenge presents itself, the family will be off on another grand adventure and the telecoms industry will breathe a sigh of relief that she turned her back on academia in favour of working with "the team".

Eibhlin Byrne

Eibhlin Byrne worked as a teacher, before returning to college to take a Masters in Equality Studies. After that, she worked with the Depaul Trust before moving to her current position with the Daughters of Charity. A multilinguist, she en- *tered politics in 2002 and was Lord Mayor of Dublin until June 2009.*

"We all leave some legacy."

IF I WERE TO FIND THREE WORDS which reflect Eibhlin Byrne's life, and it would be difficult, I think I would have to settle for respect, loneliness (or perhaps isolation) and legacy.

She speaks movingly and with sincerity about the need for us each to respect the other – respect the per-

son who has less than you, whose culture is different than yours, who holds alternative views to yours, and respect their achievements.

There is also a thread of loneliness and isolation running through her life – the loneliness of her mother when she moved to Dublin, the alienation that she felt when she was going to college, her own loneliness when she gave up teaching, the isolation of people who live in the capital city and the need for an integrationist policy.

And she is big on legacy – this woman wants to leave a legacy behind her. In everything she has done and every position she has held, she has sought to improve the lot of people, empower them, offer hope and provide solutions. It is little surprise that she found herself Lord Mayor of Dublin (2008–09) and impossible to predict where the years ahead will take her.

Eibhlin Byrne is the eldest child of a Donegal mother and a Kerry father. Born in Inch Island, Donegal, her father worked on the Donegal/Derry border. Inch Island, on the Inishowen peninsula, is connected to the mainland by a narrow causeway. It is midway between Buncrana and Derry City.

The family moved to Dublin when she was four years old. She is the eldest of three. Her sister Marie was about two years old then, her brother Dermot was born later in Dublin. He is the only "real Dub" she says and "God help him, anytime there was a match in Croke Park his Kerry uncles and his Donegal uncles gave him

an awful time. Mind you, I have to say, he held the fort strongly and kept the Dublin colours flying."

Her father had been working on the border, and was transferred to Dublin to take up a position as the Automobile Association officer at Dublin Port. She can still remember how devastated her parents were to be leaving Donegal and the friends, family and social network that they had built around them. "The men who worked with my father at the border going from Donegal to Derry all came out to salute him when he was leaving. Probably my earliest memory as a child is of the sadness of my parents leaving the security of Donegal and coming to Dublin where they knew absolutely nobody. I know from listening to my mother that it was a very, very lonely time bringing up children without your family around you," she said.

Every year, her father got a gift at Christmas from "the 12 apostles". "What happened," she says, "was that, after my father came to Dublin Port, they decided to develop the roll-on roll-off car ferries and a lot of the dockers were going to lose their jobs because they couldn't drive. So, my father taught them to drive and, as an act of gratitude, every Christmas they sent him a hamper from "the 12 apostles". So, you see, a Kerryman did some service to Dublin!"

As Lord Mayor, she later met some of the men when she was visiting Dublin Port. These men had known her

father 30 years previously and remembered his kindness.

There were no politics in her household when she was growing up. "My father would probably be a blueshirt, his family are staunch Fine Gael down in Kerry," she says, "and my mother, possibly being northern, would be Fianna Fáil, but it was certainly not a political background at all. I think people in those days, families like mine, were too busy trying to live and bring up kids."

When they lived in Donegal, her mother had taken in foreign students to make some extra income for the family. After they moved to Dublin, Aer Lingus asked her mother to look after a group who were visiting the city, so she began taking in groups and organising programmes for them. Meeting, greeting and welcoming people to Dublin became a part of Eibhlin's childhood.

At the age of nine, her mother sent her off to a family in France – and it started a lifelong interest in languages. "My mother got the great idea that, to give me the advantage that maybe she hadn't got, she would send me off to the Pyrenees to learn French. She was a woman who was very much ahead of her time."

Eibhlin speaks fluent French, can converse in Spanish, and has a working knowledge of German and Italian. "Languages have become very much a part of my life," she said, "and are very important in terms of communication and understanding other people's cultures."

Her children have inherited her love of languages and travel. In summer 2007, her two eldest daughters spent the summer volunteering in Namibia. "Claire is studying medicine, so she went to a bush clinic and she worked with people who don't have any verbal language – they have a clicking language – and Lisa, who likes animals, went and worked in an animal sanctuary. I've always encouraged them to get out there and understand other people. For them, nothing is alien. If somebody arrived from Mars they'd say – that's very interesting, and how are things on Mars," she says.

The family were living in Coolock and Eibhlin was thinking of a career in journalism when the Stardust tragedy occurred. The Stardust nightclub on the northside of Dublin, opposite the Artane Castle Shopping centre, was engulfed in flames in the early hours of Valentine's Day, 1981. The disco was popular with locals from Artane, Kilmore and the greater Coolock area. A total of 48 people died in the Stardust fire and a further 214 were injured.

"I was from Coolock, so I knew a lot of people who died in the Stardust and (her husband) Ken's dad was the Superintendent in the Gardai at the time so we were very, very closely linked with it and it had a huge impact on the young people in our area," she says.

Because she was one of the few people in the area who spoke French, she translated for the French television stations that night. She was shocked by the way

they behaved. "I was quite horrified by how intrusive
they were into the lives of the families. As I developed I
realised that there were lots and lots of forms of jour-
nalism but that put me off that night," she said. The
translation work convinced her that this was not a ca-
reer path that she wanted to follow.

Instead, she went to college to become a teacher.
She was very conscious of how lucky she was to get the
chance. She left school in the 1970s when going to uni-
versity was not an option for most of her peers. Out of
about 95 people who were in her class at Mercy College,
only four or five went on to third-level education.

Mercy College, Coolock, had always focused on the
holistic development of their students. Their mission,
particularly for students who were marginalised or dis-
advantaged, was to help them achieve their full poten-
tial in life. It was an ethos that Eibhlin Byrne would
carry with her throughout her own teaching career.

Eibhlin studied French, economics and history at
University College Dublin. College was a very lonely
place for her. "Once you got to third level, you didn't
know very many people there. It was an alien place to
be and my memories of college life are certainly not
good memories. It wasn't a time of my life when I was
happiest," she says. Other students had things in com-
mon with each other: "My mother went to this college,
or my father went to this college, or your parents know
my parents – all those kinds of things." It only alienated

her further. "I can identify now with young people com-
ing from disadvantaged areas into third level. People
think that it's enough to give people the opportunity to
go to college, but it can still be a very lonely place if you
don't have all the social networks. Just giving people
the right to an education is not enough. Equality is
about much more than just money and educational ad-
vantage," she adds. A generation later, however, her
own children have experienced none of this alienation,
taking it for granted that their parents know the parents
of their college friends!

After graduation, she began teaching at St. Domi-
nic's High School in Sutton, popularly known as "Santa
Sabina". There she was very lucky to meet an older
teacher, Anne Wynne, who became her mentor and
taught her about managing and inspiring children. "She
was a teacher supreme. She was born to teach," says
Eibhlin. Anne became one of her closest friends.

Eibhlin taught French, economics and history. "It
wasn't so much about what I was teaching them, it was
what I was helping them to become. So for me, it was
much more about developing the individual, looking at
their strengths, and showing them ways that they could
develop those," she says.

Long before others had thought of it, Eibhlin was
teaching students about making French food and put-
ting French banners up in class. She taught human
rights 30 years ago when it wasn't even on the syllabus.

In 1987 the film *Cry Freedom* was released in cinemas. Directed by Richard Attenborough, it tells the true story of Steve Biko, a charismatic South African Black Consciousness Movement leader, and Donald Woods, the liberal white editor of the *Daily Dispatch* newspaper. Biko sought equal rights for black South Africans in an apartheid state, and Woods supported him. Biko was killed in police custody and Woods wrote a book about his life and struggles, which was one of the sources for the film.

When *Cry Freedom* came to cinemas in Dublin, Eibhlin hired ten buses and brought the entire school "just to get the kids to see what human rights in action really was," she says. "I never saw education as being about getting an 'A' or a 'B' in your Leaving Certificate. I saw it as trying to get children to see the strengths in themselves."

When her second daughter was born (she has three girls), she tried job-sharing for a year, but it didn't work out. She felt that she wasn't being fair to the children she was teaching or the children she was rearing. At the time, job-sharing meant an hour here or there so, very reluctantly, she gave up teaching and became a full-time mother. Her eldest daughter, Clare, was three years old and her new-born, Lisa, was one year old when she decided to take time away.

"I decided it very reluctantly," she says. "It was a huge financial blow, just one salary and paying a mort-

gage and all that. But it was more from my own personal perspective that I found it difficult. I had huge love for my colleagues and I absolutely adored the kids that I taught and I was very, very lonely when I gave up that teaching job. It left a huge vacuum," she adds.

Being Eibhlin, she threw herself into a whole new set of activities. She had always been involved in the Society of Saint Vincent de Paul. She tells the story of visiting a woman in Darndale who had only two sausages for her dinner. The woman offered one to Eibhin. She was left with a dilemma – should she eat the sausage and leave the woman hungry? Or refuse the sausage and the woman's generosity? She ate the sausage. "Just because you are able to give support does not give you a moral superiority," she says. "You must leave people with their pride."

When her daughter Claire went to school, Eibhlin got involved in the parents association, she got to know her neighbours and organised the Halloween Party on the road each year, she became a counsellor with the Rape Crisis Centre – and she went back to college to study for a Masters in Equality Studies. She minded the children during the day while her husband Ken worked. When he came home in the evenings, he minded the children and she went off to college.

Her thesis was on the "Role of Disadvantaged Parents in the Education system". She found that many parents with no education were so traumatised by their

own experiences at school that they found it difficult to relate to schools when their own children went. The parents became nervous and often found it difficult to attend parent–teacher meetings.

She was particularly impressed with the example she found from Denmark, where parent–teacher and parent association meetings were held in the parents' homes because they were on their own territory as opposed to having to go into a school for a meeting. "We forget that we actually only have a certain impact on the child. It is the parent who has the major impact. It's the parent we need to empower," she says. "The danger for all of us who are teachers is that we might lecture parents as well as lecture the children." We're back to the word "respect" again.

Very often, she says, parents really do know better. She tells the story of the time she was helping a child to do her homework, again in the Darndale area of the city. "What are one and one?" she asked. The child didn't respond. "What are two and two?" Again, no response. The mother, who had been listening, was getting exasperated. "You're doing it all wrong," she said. "What's twopence and twopence?" she asked. Without a second's hesitation, the child answered, "fourpence". "It's in those kinds of situations that I've learned my greatest lessons in life," says Eibhlin.

She finished her masters and wasn't quite sure what she would do next. One dark, cold evening in Novem-

ber, when she was crossing O'Connell Bridge, a young
boy (about 14 years old) asked her for money. She was
unsure whether or not she should help him. While she
was trying to decide, the boy got up and ran across
O'Connell Bridge. An older woman had also stopped
and was standing beside Eibhlin, who turned to her and
commented that the boy was going to be killed. "Say a
prayer that he will be," said the older woman. "He
hasn't got very long. He's clearly in the final throes of
heroin addiction."

The encounter had a huge effect on Eibhlin. For the
next six months, every time she went to a dinner party,
or met friends and had an opportunity to chat, she gave
out about homelessness. It shouldn't be happening in
the city. There must be a better way.

She returned to full-time employment some time
later working for the Depaul Trust. The trust works
closely with its founding partners – the Society of St.
Vincent de Paul, Vincentian Fathers and Daughters of
Charity – to help the homeless. She says that she was a
typical middle-class person with pre-conceived notions
about homelessness. "I met company directors and
teachers," she says, "and street drinkers. They were the
greatest characters of all." For whatever reason, street
drinkers are addicted to alcohol and will never be cured.
But they need somewhere to live – including the only
wet-house in Dublin in Aungier Street – which was
opened by the Depaul Trust in December 2002.

She is currently working with the Daughters of Charity Child Services, managing ten centres which look after families in crisis. Many of these children have been traumatised, quite a few have witnessed shootings, some have seen their father kill their mother, others are working through parental break-ups. The centres help them and help the parents with parenting skills. She has come full circle back to working with children and empowering them for life.

When she was teaching, she had always encouraged her students to become politically active and get involved in the argument. To participate in life and not be a bystander. "You owe it to yourself and, most importantly, to your community and your country, to get involved," she says. It didn't matter which party they chose, so long as they joined. "I get very annoyed when I hear people criticising the system and constantly having a go. It's interesting to a point and then it gets completing wearing. I really feel like saying, 'and your point is?' Negativity is very easy. We can all find ways to criticise but being the one who is the builder, the creator, the believer is a lot, lot harder than being the destroyer and the critic." It drives her mad when people "shoot from the ditches. In the end, someone has to get into the trenches," she says.

She takes advantage of every opportunity that she gets to talk to teenagers. "What I say to them is this: If you were around when the Jews were going to the con-

centration camps, if you were around in 1916 when there was the Rising, would you have been the person standing on the street or would you have been the person being involved? Every moment that you live is a defining moment of history and you've got to play your part in it."

She became a public representative when Sandra Gerraghty stepped down from the City Council and she was co-opted to replace her. Ms. Gerraghty had been a City Councillor for six months and she had not found it easy. Eibhlin Byrne fully understands. "There is a high turnover of councillors," she says. "We've lost seventeen of the fifty-two councillors since I joined the Council and we've lost some great women. That's not to take from the women who are there, including myself, but some very good women have gone," she says.

Politics is not an easy life for women. "Women have a particular way of working," she says. "If they're going to give up time and be away from their families, they want to see progress and very often we get frustrated. We want action." Women are results-driven, she says, and that is not the way of politics.

People have said to her that they don't know what she is doing in politics. She has everything, what's the point? Because she has everything, she has a duty to give something back to society. That's the point, she believes.

She has had some major setbacks along the way. She worked hard for the creation of an Older Persons Commission only to see it introduced and, within a month, abolished. The person who had been appointed as Older Person's Representative was removed and put back into their old job. It is undoubtedly annoying, frustrating, downright infuriating, in fact, when something like that happens, but she is a fighter. She will stay with the system and try to change it back again.

She is still appalled at the homeless situation in Dublin. "We spend sixty million euro on homelessness in the city," she says. "There are a thousand people working on it, and there are only twenty-five hundred homeless people. Half of all homeless people are in emergency housing where no one checks on them each day," she says.

Perhaps her biggest concern is with the sort of city that Dublin might become. "Are we as open as we could be?" she asks. "Are we going to be multicultural or are we going to be integrationist? We need to work at integrating people into the city because otherwise we will have all of the challenges that cities like Paris and Birmingham have faced. I think we need to be very clear on what the culture for Dublin going forward is going to be, what we want Dublin in the twenty-first century to be, and they are not things that will happen by accident. They are things that will happen because we planned them."

"We need to put the structures in place, we need to have the dialogue and hear everybody's view but then, the city needs to show leadership. It is a huge task and I think it's one we are backing away from because we're afraid that we may fall into racism or we may challenge each other. We will grow as long as we all keep the big 'R' in mind – respect for everybody. As long as everybody respects the views, the cultures, the opinions of everybody else, we'll be fine. Whether it's those that support incoming multicultural communities or whether it's those people that feel they've always been part of Dublin, neither group is entitled to the entire say over where the city is going in the future. It's going to be that kind of combination of all of us that will give us the kind of city that we want."

Eibhlin Byrne loved being Lord Mayor – but surely a "Lord" is a man? When I asked her about the title, she told me that, by charter, the official title of the person who is in charge of Dublin City Council is "Lord Mayor", and the official title of their escort is "Lady Mayoress". "Ken Byrne gets official invitations to attend functions as the Lady Mayoress," she says. "He's very relaxed about it."

Eibhlin tells the story of the two old dears from Dublin, who sat behind her at a poetry reading one evening. Chatting to each other, one of them commented on the fact that Eibhlin's title was the Lord Mayor. "What does that make him?" she asked, referring to

Eibhlin's husband. "Oh, if she's the mayor, he's the stallion," said the other one. She laughs heartily as she tells the story. She obviously enjoys Dublin wit.

Her year as Lord Mayor ended in June 2009. During her tenure, she tried to be a voice in the Mansion House for the local communities that she has "huge time for". She prioritised issues like homelessness and participated in the "pitch" to win European City of Science status for Dublin in 2012 against stiff competition from Vienna. During her term as Lord Mayor, Dublin got City of Sport and was nominated by UEFA for the Cup Final. "Yes, there are difficult times economically, but we've had a lot of success and we need to talk about those things too!" she says.

For a politician representing one party (Fianna Fáil) she is not a "died in the wool" party person. In fact, when asked to give advice to people entering politics she has words of caution: "Don't go in too young. Discover the issues that you are interested in. Go into politics to change those issues. If you have a philosophy then you know what you are fighting for. Find the philosophy and you will find the party where it fits best."

The greatest challenge facing her, she believes, is to find new ways to contribute and adapt to a world tomorrow that will bear no relation to the world of today. "Finding my role in that change" is the next challenge she will face.

She draws on Irish and French presidents to make her point. "There's this concept that it's the Eamon de Valeras, the Giscard d'Estaings and the Charles de Gaulles of this world who leave legacies. We all leave some legacy. As you go around the city and meet the women in O'Devaney Gardens, or the women in Clontarf, East Wall, Darndale and Donnycarney – there are so many women who are leaving lasting legacies in their communities because of some little good that they do," she says.

"We come into the world alone, we go out on our own, and the only thing we can leave is whatever we have done to make life a little bit better for somebody else along the way," she says. We're back to the themes of respect, loneliness and legacy.

Gina Quinn

Gina Quinn's background in psychology led her into the field of market research, initially with Lansdowne Market Research and later with the Irish Trade Board. Shortly after joining the Rehab Group she became Chief Executive of Gandon Enterprises, *their commercial wing, a position she held for seven years. Since 2000 she has been CEO of Dublin Chamber of Commerce.*

"I want to help and understand people, not just work with them."

G INA QUINN IS A DUBLINER. Born in the Coombe Hospital, she briefly lived in Rathmines before the family moved to the new suburb of Clonskeagh when she was three years old, where she remained until after she graduated from college.

Clonskeagh, from the Irish *Cluain Sceach,* meaning "meadow of the whitethorn", is on the southside of the city and is bordered by the Belfield campus of UCD, Goatstown, Dundrum, Roebuck and Windy Arbour. In the 1970s, the area was being newly developed with low density housing. Today, Clonskeagh is quite a multicultural area which is home to the Islamic Cultural Centre of Ireland, St. Kilians Deutsche Schule and the Lycée Française d'Irlande.

Her father was a chartered accountant, and worked in the oil and coal business with Tedcastles Oil for most of his professional career. Her mother worked as a bookkeeper for Sybil Connolly, who opened her own fashion house on Merrion Square in 1957. Sybil Connolly was internationally renowned for dressing people like Jacqueline Kennedy, the Rockefellers, Merle Oberon, Elizabeth Taylor, Dana Wynter and Julie Andrews. As was expected at the time, her mother ceased working when she married. Although both parents had financial backgrounds, it was her mother who managed the family finances at home.

There were four children in the family. Gina is the third child. An older brother, sister and Gina are all quite close in age, and then there is a five-year gap to her younger brother. Her sister is Liz Quinn, one of the founders of Quin and Donnelly, the fashion design label formed in the mid-1980s. It now outsells all other design labels in Ireland, and is the biggest selling Irish de-

sign label in the UK. Her two brothers are in business together in the audio-visual and sound equipment business. The family are all very close to this day, possibly helped by the fact that all four live in Dublin.

Gina had no idea what she wanted to be when she was growing up. "I remember once, standing in the kitchen, and asking my mother did she think I was pretty enough to be an air hostess?" she says. Irish people didn't travel much at that time (except to emigrate) and an air hostess was seen as a terribly glamorous job.

"But I didn't really have a clear ambition," she adds, "other than going through secondary school. I knew that, whatever I did, it would be with people. I was very interested in people and their behaviour." That's probably what led her to a psychology degree.

Gina took her degree at University College Dublin, the college which had been opened for Catholic students on St. Malachy's Day, 1854, and which was practically on her doorstep. The study of psychology involves understanding how the brain works, how our memory is organised, how people interact in groups and how children learn about the world.

It was perfect for Gina. She was very interested in the whole area of behaviour and "how people react to things and I also had a sense of wanting to not just work with people but help and understand them," she says. When she embarked on her course of study, she thought that she would probably work as a psychologist

helping people to sort out their problems. She has never worked as a counsellor but says that "even in professional management, one is a counsellor at times, motivating and encouraging colleagues and helping them to develop their careers." She has used her skills in the business arena all her working life.

She graduated with a BA in Psychology in 1980 and went to work with Lansdowne Market Research as a qualitative researcher, working closely with marketing professionals in the fast moving consumer goods (FMCG) sector. She was working on behavioural market research, doing group discussions and trying to understand consumer behaviour. "I was going back to marketers and saying, 'your advertising is working because they like A, B and C, or they don't like A, B and C and you should be thinking about repositioning your brand or you should be thinking of repositioning your advertising or pubic relations in a certain way'," she says. It allowed her to use her skills of analysis of behaviour and attitudes in a business marketing area.

She loved the job. It gave her an insight into other professionals in the marketing area and the whole area of brand development. It was a time when Ireland was really only developing its identity as a marketplace. For a very long time, Ireland was treated as an annex of the UK in terms of a company's marketing and sales activity.

"If you like, I was able to stand in the middle of business people on the one hand who were trying to achieve certain objectives and the consumers they were trying to get, and help them reach those objectives," she says. The core skill that she learned, she says, was listening. "It's a very valuable skill to be able to listen and observe – as well as being able to ask the right questions," she says.

Another part of the role which stood to her was that, for every project, she had to present back to the client and that taught her presentation skills. "We all know now, when we look at Barack Obama or any of the great communicators of our age, how important communications skills are, but many of us come out of school or college without having developed those skills," she says, adding that they are now taught at post-graduate level.

In 1984, she moved to the Irish Trade Board (now Enterprise Ireland). The Trade Board was a resource for established and new companies in three key areas: creating market awareness for individual companies; developing knowledge and understanding of markets; and helping build profitable sales and effective marketing capabilities for client companies.

Working with the Trade Board gave her a broader insight into what businesses were doing. She began working in the newly created market research division, looking at ways of providing information on markets for Irish exporters. To do that, she needed to understand

what exporters were looking for so that she could iden-
tify the markets that would suit them.

Most of her research was done for the food and cloth-
ing sectors, particularly consumer products in the food
area. Ireland was well known as an exporter of commodi-
ties at the time. Beef, milk products, Guinness, Water-
ford Glass, traditional tweeds and clothing from the
weaving industry were well established. It was an inter-
esting time. Newer industries, speciality artisan food
products, were beginning to emerge. One of these was
Lir Chocolates, a company established by Mary White
and Connie Doody in 1987, which began life in the ki-
chen of one of its founders and grew into a business with
a multimillion euro turnover which supplies product to
many of the leading Irish and UK supermarkets.

The markets under research at the time were mainly
European and American markets. Asia had not yet been
identified as a market. There was a little research on
Japan, says Gina, but definitely nothing on China which
wasn't an open market at that time.

She travelled a little when she was working there,
but not much. The Trade Board had a network of offices
in different countries. She would have spent time in
some of the European markets and in the USA, but it
amounted to days or possibly a week or two, never any
longer.

At the same time, she started studying for her mas-
ters. She hadn't really thought about it, she says, until a

friend suggested that she should consider it. "I was getting to the stage in my career where I was building up a level of expertise, but I was very conscious that I didn't have, particularly, the financial base that anybody with a commerce or engineering degree would have," she says. "So that was both the most interesting and challenging part of my MBA programme for me."

She returned to UCD, to the Michael Smurfit Graduate Business School, to take a Masters in Business Administration (MBA) part-time, over two years. She found it very intense and says that, sometimes, it was hard to credit that she was doing it part-time. "I suppose it says something about me. Give me a target and I'll go for it," she says. She enjoyed the course and the studying. "I probably enjoyed it more at post-grad level than at primary level," she says. She loved the cut and thrust of group work and the interaction in class. The communications and presentation skills that she had learned in her earlier working life helped her enormously. "While the engineers in the class were excellent at crunching the figures, they hated getting up on their feet. So I'd be the first up and, at the end of the day, you know, often it's the messenger who gets the praise for the message – as well as getting shot when the message goes wrong. So, it works both ways," she says.

She met her husband in UCD when they were both studying psychology. He is a practicing psychotherapist. They've been married 24 years and have three girls,

"three fabulous daughters – Alice, Georgie and Julie". She had her first child almost nine months after she graduated from the MBA.

She moved jobs immediately after she completed her masters. "When you do a degree like that it opens up your horizons. I was also looking for something that had the potential to give me more management experience so, while I went into Rehab originally in a marketing role, and then took on marketing and sales management, I moved to a more general management role very quickly, within the first year," she says.

The Rehab group started life as the Rehabilitation Institute in 1949 to support people recovering from TB and help them re-enter the workforce after their illness. Starting in Dublin, it expanded into Cork and Limerick in 1952, the same year in which they launched a football pools competition which was Ireland's first nationwide lottery operation. Nowadays, Rehab provides services in more that 200 locations throughout Ireland, the UK, Poland and the Netherlands.

Frank Flannery was Chief Executive of the Rehab Group when she joined. A well known and highly respected business leader, he had joined Rehab in 1973 and was more than 25 years their chief executive when he retired at the end of December 2006.

It was clear to both Gina and Frank Flannery that commercial businesses employing people in the area of disabilities throughout Europe and the USA had a very

different approach to the one that was being applied in Ireland.

They started looking at how to upgrade their commercial activities and create a sheltered employment environment for people with disabilities which would give those people a strong sense of purpose, independence and usefulness.

The model they designed was integrated sheltered employment where 50 per cent of the workforce had a disability and the other 50 per cent were able-bodied.

The business concept was quite a simple one. Over a period of many years, Rehab had built up a body of businesses that had some commercial element to them. These were being run within the organisation on a localised basis as a way of contributing to the overall running costs of Rehab. They were in virtually every town in Ireland. Gina and Frank checked them all out and picked the six best businesses in terms of their commercial performance and potential. The six companies chosen included Rehab Recycling Partnership, which at the time was rolling out the bottle bank structure to the whole country.

They proposed restructuring these to bring them into a small conglomerate where they would share HR, finance and overall management resources, and Rehab could make it sit together as a business group. They called it Gandon Enterprises. It was the first time that a scheme of this type had ever been introduced in Ire-

land, and they needed government support and assistance to make it work.

If Rehab had gone straight down the road and employed people with disabilities in this way, they would have lost their social welfare benefits and those had to be protected in some way.

So they pulled out the full business plan for this "entity" and pitched it into government. Gina literally went to civil servants and lobbied them, telling them, "I think this is a great idea, and this is why, and I'd like you to support it". The lobbying paid off, and the government brought together a multidisciplinary team made up of representatives of the Department of Finance, the Department of Enterprise and the Department of Health. This in itself was a big move as it was one of the first times that the government ever created this type of team. Traditionally, disability would have been seen as a health issue.

Gandon Enterprises hadn't existed when Gina joined the Rehab Group. Having brought it from concept to fruition, she now wanted to lead it. She viewed it as her baby in a way. The interview panel saw it the same way, and she became chief executive of Gandon Enterprises, the commercial wing of the Rehab Group.

"One of the first things that we did, as a team within Gandon Enterprises, was ensure that the quality criteria were achieved in the businesses," she says. "At that time, ISO 9002 was the quality certification that any

manufacturing environment needed to have. So, in the early days, we put a lot of effort into making sure we had all of the standards that any regular business would have. We didn't want any exceptions. We didn't want customers to accept anything that was less than as good as our competition." They set the bar very high, but the rationale behind the decision was clear. Gandon Enterprises did not want to secure contracts and handle work because they were "worthy"; they wanted to win the business because they were quality assured and operated to the highest standards.

The most satisfying part, for Gina, was the buy-in from employees, the pride with which every single employee approached the whole business of getting that certification. "I can remember one story of a manager telling me how, on the morning of the audit – this was the first company to go through the formal audit – he arrived up to the plant very early in the morning, about 6.30 am, expecting to be the first in, and finding that the lights were on in the plant and cursing under his breath that 'someone had left the lights on last night, what a waste', but finding that he wasn't the first in. The first people in were some of his employees who had a disability who were just so engaged and involved with the process that they wanted to make sure that everything was absolutely perfect," says Gina, adding that they passed first time. "It was a great moment of celebration. It was a very rewarding environment to work in."

She had, and still has, a huge admiration for the work of the Rehab Group. When she was about 10 years with them, having spent about seven years as chief executive of Gandon Enterprises, she felt that she had achieved a lot, but she needed a change.

Gandon Enterprises (now re-branded as the Rehab Enterprises Group) is the largest single employer of workers with disabilities. Some 361 people are employed under the Rehab Enterprises umbrella, of whom 210 have disabilities.

Through a series of coincidences, she ended up talking to the Dublin Chamber of Commerce who were looking for a chief executive. She took up her new position as CEO in 2000. "It gave me an opportunity to harness my Dublin roots and also a chance to look at different parts of my own skill base," she says. There are 22 people employed by Dublin Chamber, which operates as a small business in itself. It is governed by a council which includes representatives of some of the biggest businesses in the capital. In effect, the council is Gina's Board of Directors.

The Chamber represents the business interests of 1,400 companies across the Greater Dublin area. "About 65–70 per cent of the membership of the Chamber are actually SMEs, so we have a very significant base among small business. Our whole programme of activity and lobbying to Government is very much fo-

cused on meeting the needs of SMEs as well as of larger businesses," she says.

The Chamber has three key areas of policy that it focuses on: transport, competitiveness and the knowledge economy. These three are vital for the long-term future development of the capital city, they believe. While they concentrate on these areas, they will also offer comment and opinion on anything else that affects Dublin and its business community.

Formed in 1783, Dublin Chamber was the first chamber in the whole of the UK and is the oldest and largest chamber of commerce in Ireland. Gina proudly points to the Chamber's history and to the history of Dubin city business people. The current Chamber President is P.J. Timmins of Clerys on O'Connell Street. "Clerys is the first purpose built department store in the world," says Gina. It was built in 1853 when "Dublin was at the peak of sophistication," she adds with pride.

Gina says that the best advice she could give anyone in business, and women in particular, is to be "open to opportunities and go for them. Sometimes we don't actually harness our ambition effectively as individuals. We don't always harness our potential. One of the things that my mother taught me is – why not? Go for it. Try it. What is the worst that can happen to you? Someone will say no. But you might find another way of asking the same question and they might say yes to you the next time."

She also has a strong belief in education and lifelong learning of all sorts. "I will always look on people's CVs to see the other things they do apart from their work. It's not always about getting other degrees or post-graduate education or doing business-related courses. It might be taking a course in philosophy or doing a dance class. It's about challenging yourself and always trying to learn something new."

And she practices what she preaches. She does a lot of different courses each year with work, and learns a lot through conferences. So, she says, a lot of her "learning" would be business-related. But, she is currently taking ballroom dancing classes with her husband and is trying to revitalise her school French.

She believes passionately that Irish people are uniquely positioned to become world-class networkers. "I really believe in Ireland that we have a unique cultural advantage in developing networks and developing relationships. It works hugely for us in business. It has worked enormously for us in developing our foreign direct investment profile. It has worked hugely for us in the European Union. It works with us in our diplomacy worldwide. It even worked for us in solving the problem of Northern Ireland where we were able to pull in all this international help to sort things. That is a strong platform for our future," she says.

Gina is a woman who puts a lot of time back into business and the community. She has served on a num-

ber of boards, including the Dublin Docklands Author-
ity, the Irish Council for Civil Liberties (ICCL) and An
Bord Bia. She also mentors MBA students in UCD. "I
have a real commitment to education and I feel it's very
important to put something back into that," she says.
"I'm mentoring two students at the moment who are
doing the MBA and I have also done some trial inter-
views with other students. It's fascinating. I mean, it's
fantastic to be privileged to have an insight into some-
one else's career ambitions in life and to have the op-
portunity to comment, observe and offer feedback. I'm
sure that about ninety per cent of what I say gets
ditched – but if even five or ten per cent sticks?"

For relaxation, she travels the world. "I love the
whole experience of other cultures and understanding
how other people see the world. I've always enjoyed
travel and I've been very, very lucky. I've got to most
continents in the world – but I've never actually been to
India," she adds, with a twinkle in her eye.

She has achieved a lot, but she looks back to her
time with Rehab with greatest pride. "The fact that I
was working with people, at that time, who might not
have got the opportunity they did, were it not for the
drive of the organisation. I'm very proud that I was part
of that drive," she says. We are back to the psychology
degree and the reason she embarked on her chosen ca-
reer – to help and understand people, not just work
with them.

Ivana Bacik

Ivana Bacik is a barrister, qualified to practice in England, Wales and Ireland. She is author or co-author of almost a dozen books. She is Reid Professor of Law at Trinity College, and also an elected member of Seanad Éireann.

"I was naturally quite argumentative so practicing law really attracted me."

AS YOU WOULD SUSPECT FROM her surname, Ivana Bacik has roots in the Czech Republic. What you might not suspect is that her grandfather was the founder of one of Ireland's most iconic brands.

Ivana's grandfather Karol (or Charles) was born in Czechoslovakia. Her grandmother was Croatian with some Croat and some German in her background. They were very much a typical central European mixed an-

cestry couple. What made them slightly different was the fact that they had met when they were both studying in Charles University. Charles University was established in 1348, the first university north of the Alps and east of Paris. Her grandmother was one of only a handful of women in the late 1920s to go to university. "She used to laugh loudly as she told us that she had her pick of men," says Ivana.

Her grandparents and their children – her father and his brothers and sisters – lived in Prague. Prague is built on the River Vltava in central Bohemia, and has been a centre of commercial activity for over 1,000 years. It is the capital of the Czech Republic with a current population about the size of Dublin (1.2 million).

Karol Bacik owned a number of glass factories in Bohemia and was a well-established businessman.

Hitler ordered Germany's army to enter Prague on 15 March 1939, and, declared Bohemia and Moravia a German protectorate. Ivana's grandfather joined the Czech resistance and was imprisoned by the Nazis. On his release after the war, he realised that factory owners would not be very popular under the new communist regime, so he brought his young family to Ireland. Ivana's father was four years old.

Karol Bacik knew that there had been a glass factory in Waterford previously which had been established by the Penrose brothers, George and William, in 1783. Penrose Crystal, in its day, was highy regarded

throughout Europe and America, and had won several gold medals at the Great Exhibition in London. The factory had closed in 1851, but the history of crystal making in Waterford was well known to people in the industry. Ivana's family still have some pieces of Penrose Crystal.

So, her grandfather came over after the war in 1946 and set up the factory in Ballytruckle in Waterford with the help of some Irish entrepreneurs, including Senator Joseph McGrath with whom he had previous business connections.

Her grandfather also brought over some of the master craftsmen from the Czech Republic, many of whom he had previously employed. In fact, the chief designer of Waterford Crystal, Miroslav Havel – the man who created the Lismore Suite – was one of the first to arrive. He, in turn, trained many of the Irish designers and crystal cutters. In 1977, when Havel retired, there were 3,430 people working in Waterford Crystal, which accounted for one in every 10 of the city's population at that time.

Eventually, Ivana's grandfather was bought out by the McGraths who owned the factory in the 1950s and 60s, but he remained a manager there. He also became a director of the company, a position he held until his death in 1991.

Ivana's father resisted the lure of crystal. He had always been drawn to physics. There is definitely a

mathematical "streak" in the family. Both of her grand-
fathers studied engineering (including Karol), and two
of her brothers are engineers. Her father became a
physics teacher. He still lectures in physics in the Dun-
dalk Institute of Technology. Ivana's mother, a pharma-
cist, is a Murphy who grew up in Co. Clare.

Her maternal grandfather was from Monaghan, and
her grandmother "was from Westport via the curragh in
Kildare so there's a long history of different counties
there," says Ivana.

Ivana's parents moved to Cork when they married
and she went to national school in West Cork in Crook-
stown, about six miles east of Macroom.

Ask anyone and they'll remember one or two inspi-
rational teachers, who often underestimate the huge
influence they have on young minds. Ivana encountered
her first strong external influence in that little national
school. "Padraic Kierse was the headmaster of the little
national school in West Cork, Kildug National School. It
was a very small, rural school. Mixed classes of boys
and girls. He was very ambitious for all of us," she says.

Ivana is the eldest in the family of four. There are
two boys and two girls. When she was 11, she won a
scholarship to Alexandra College in Dublin and went
there as a boarder. The family moved to Dublin three
years later, and she continued in the school as a day
girl. Her mother's family had all moved to Dublin by

then and they didn't have much family in Cork so it was a natural progression.

Alexandra College in Dublin was founded in 1866 to educate young, middle-class ladies in Ireland. It is a private, all girls, fee-paying secondary school which has over 600 students, of whom 170 are boarders. They proudly boast that "over 90 per cent of our Leaving Certificate students proceed on to third level". Their students achieve average points of "435 each year – compared with a national average of 300," they say.

"Alexandra has a long history of educating women, especially in the early twentieth century when women weren't being educated for anything other than child-rearing and marriage. Looking at the history of it a little more, it had really offered effectively a third level education for girls at a time when they couldn't go to university." says Ivana. "Alex had a good reputation for that tradition of educating women, and a lot of the teachers would have been strongly keeping to that tradition," she says.

She was interested in politics and current affairs generally from an early age. "I remember great debates in secondary school about the anti-abortion amendment when I was in third or fourth year in 1983," she says, adding that "I had strong views and I was quite argumentative so law naturally attracted me for those reasons".

Her family were also political "with a small p", she says. Her mother has always been and remains a very strong feminist. "We would have had current affairs and political debates at home," says Ivana.

She had a wonderful history teacher in Alexander, Anne O'Connor, who really inspired a lot of the students to go on and study history, or subjects which had a lot of history in them. There's quite a lot of legal historical research in law. She was 17 when she went into Trinity College to study law. Trinity College, Dublin was founded in 1592. It is ranked as one of the top 100 universities in the world.

She was in college during the 1980s recession. There weren't many service industry jobs available at the time, but Ivana was lucky enough to hold one of them. She worked part-time as a waitress in MacArthurs Restaurant on the corner of Dame Street and South Great Georges Street. "It was briefly famous because it featured in *Educating Rita*. The restaurant where Rita worked had the 'front' of MacArthurs although the inside was completely different," she says.

While she was studying, she got involved in the Labour Society. Dick Spring was the leader of the Labour Party at the time. She had met a group of very active party members and was keen to get involved. "My mother always had leanings towards Labour. We were quite a left, liberal house. There would have been a lot of admiration for Garret Fitzgerald (Fine Gael) too in

our house because of his liberal agenda in the eighties," she says.

"Labour in Trinity was very radical. Very left wing, very active," she says. "I became chair of it in my fourth year. We used to try to build some sort of alliance between ourselves and what was then the Workers Party and others who were in other socialist groupings within the college." She thoroughly enjoyed it.

She also had very political lecturers in Law School in college who influenced all of their students. Kader Asmal was a particular influence on Ivana. He was born and raised in apartheid South Africa, and had left it in 1959 to study law at the London School of Economics. In 1963 he accepted a teaching post at Trinity College and taught there for 25 years. He had a very high public profile in Ireland as chairman of the anti-apartheid movement. He later returned to South Africa where he held two Ministries in the ANC government.

"I've seen him out there and he's in his element," says Ivana. "I asked him once did he miss Dublin and he said – well, I miss the people, but it's great being a Minister."

She is an enormous admirer of Archbishop Desmond Tutu whom she met in early 2009. She told him that the last time they were in the same space, he was addressing the Nelson Mandela 70th Birthday Tribute Concert in Wembley Stadium in London in 1988, and she was one of about 200,000 listening to him speak.

He remembered the rally, and in particular he remembered Trevor Huddleston, one of the other speakers, a well know anti-apartheid campaigner, saying "this will be one of Nelson Mandela's last birthdays in captivity". Everyone thought he was mad. Mandela had been in prison decades at that stage. He was released in February 1990 – 18months after the rally.

While she was studying at Trinity she also got involved in the students union. "I liked their methods," she says. "In the eighties they were out on the streets, protesting. At the time, third-level tuition fees were still in place and they were going up ten per cent each year and it was becoming quite onerous. Those of us living in Dublin didn't have the high expenses of those living away, but students used to go abroad every summer to earn money towards fees and their own upkeep for the coming year."

Once she was actively involved, she says it was then "a natural progression to run for president of the Students' Union" when she was in fourth year in college. The presidency of the Students' Union was a full-time position. "You took a sabbatical year and you were paid what seemed like a fortune of £70 per week at that time," says Ivana.

A big legal case had been brewing before she took office in 1989. SPUC, the Society for the Protection of the Unborn Child, had threatened her predecessors with legal action. At the time, the only place where in-

formation on abortion (in England) was available was from student unions. They were the only ones left. All of the other places who had been offering information, like women's counselling centres, had been closed down by legal action taken by SPUC under the constitution following the 1983 amendment.

"By 1989, students unions were the only places brave enough to offer this information publicly and accessibly to women," says Ivana. "I remember the dreadful trauma of the women ringing, and we would have four, five or six women a day sometimes, ringing us in tears and in great distress, looking for information on where to get an abortion. These were women who would have been pregnant in a situation where there was a crisis, where they needed to terminate the pregnancy and the only place they could go was to Britain because then, as now, abortion remains illegal in Ireland." But, at that time, giving the information was illegal.

The Students' Union always knew they might be targeted by SPUC. Very shortly after she became president, just a few months into her term, they were taken to court by SPUC and threatened with prison for breaching court orders.

"I remember somebody coming to us, someone who had been in prison for some years, in the women's prison, and telling us that conditions at the time were absolutely appalling. We had no inkling of this," she said. And this person told herself and her colleague, the

deputy president, "you must on no account go to prison because you will be ripped apart in there".

"We were certainly scared about prison but, at the same time, we felt we had a duty to our members in the Students' Union who were supporting us and we believed in the bigger cause of a woman's right to receive information," says Ivana.

In the end, Mary Robinson stepped in to defend them. She successfully argued that there was an issue of European law. "She argued that we were simply giving information on a service which was legally available in another member state of the European Community." The case then went off to the European Court of Justice where, Ivana says, they eventually reached a "neutral" decision. In effect, they said that, "Yes, there is a right to give information but there was no economic link with the service provider so it was really outside of the scope of EC law".

By that time, however, the X case had happened, the people had voted in 1992 to make information available, and things had moved on. "But I like to think that our case had helped to change attitudes in favour of information because we took a very public campaign," she says. She also praises three politicians, in particular, for their public support of their campaign at the time: Monica Barnes, a Fine Gael TD for Dun Laoghaire; Ruairi Quinn, a Labour TD for Dublin South-East; and Proinsias de Rossa, a Workers Party and later Democ-

ratic Left TD for Dublin North-West. (Proinsias de
Rossa is now a Labour MEP for Dublin).

The students had been placed under an injunction
and were listed in Stubbs Gazette of bad debtors. Two of
the four Students' Union officers were law students, and
some USI officers were law students too. After gradua-
tion, they might have found it difficult to practice as so-
licitors in Ireland. However, there was a recession,
there were no jobs available, and most of them were
looking to emigrate. Any graduates that Ivana knew
who stayed in Ireland were on the dole or were working
part-time.

Ivana emigrated to London. She took a masters in
the London School of Economics. Kader Asmal had
studied there and used to tell great stories about the
political nature of the college. And there was no Irish
equivalent of the courses at LSE. "They had strong
courses on law and social theory, and labour law which
I was very interested in at the time," she says.

While she was studying by day for the English bar,
she took up her first teaching job, part-time, in the
Polytechnic of North London which later became the
University of North London. That polytechnic had a
very diverse, very mixed student body. She was teaching
night students, for whom she has great admiration, and
she realised the she loved teaching.

After that, she did seminar teaching at the Univer-
sity of Kent, which was a critical law school. She found

it particularly interesting because the school taught law from a critical left-wing perspective

Qualifying for the English bar was easy, she says. "England and Wales is one jurisdiction and that's easy for an Irish law graduate to convert to practice in," says Ivana, "but Scotland is different".

She was trying to start practice in London at the same time, and found that very difficult. There is a chambers system in the UK, which operates along the lines of a partnership. The chambers have offices. They might have 20-30 barristers in one chambers. She did her pupilage (her apprenticeship – the equivalent of "devilling" in Ireland) in very big civil liberties chambers. In London, the clerks in the chambers talk to the solicitors and they apportion the work and handle discussions about fees. You don't need contacts, and equally as important when you are just starting out, they pay you a wage. There is a certain security attached to working in chambers.

However, lawyers are expected to work full-time. In Ireland, you can teach and practice, but it the UK you are expected to do either one or the other. She was three years in London. It was 1993 and it was time to come home.

She came back to teach in the National College of Industrial Relations (now the National College of Ireland). Joyce O'Connor recruited her to the lecturing position at the college, which was then based in Ranelagh.

NCIR had a very diverse student body. There were a lot of second-chance and mature students learning law, a similar student profile to the courses she had been teaching in London. She was very comfortable there. During her time with the college, she started up a Certificate in Women's Studies and found Joyce O'Connor hugely supportive.

She also began practicing at the bar. The Irish system is very different to chambers. Each barrister works from the Law Library, is self-employed and typically answers to no one. Nobody finds work for them and they do not have the luxury of a weekly salary. Typically, barristers get work through the master–devil relationship (apprenticeship), but it is undoubtedly harder to get started in Ireland.

Ivana is currently Reid Professor of Criminal Law, Criminology and Penology at Trinity College. The position was created by a philanthropist from the nineteenth century, James Reid, who gave the money to Trinity to set it up. He specifically required it to be given to someone who was also a practicing barrister and who had an interest and expertise in criminal law and criminology. The criteria has changed over the years. It used to also include evidence, but that's gone now, and it used to be a fixed term (temporary) position but it was permanent when she applied. The requirement to be a practicing barrister remains though.

To "win" the Reid Chair, Ivana was required to give a mock lecture to people who are already lecturers in the Law School and other departments in Trinity and to answer their questions at the end. She then did an interview. It tests your teaching skills, she says, but that is what you are being recruited for.

As Reid Professor, she followed in the footsteps of Mary Robinson (who had taught European Law) and Mary McAleese (who had taught criminal law). Both women were later to become President of Ireland. Mary McAleese, in fact, was her tutor when she started in college "and was a great role model," says Ivana.

When she came back to Ireland, she re-joined the Labour Party and felt it was "natural" to run for one of the university seats in the Seanad as a Trinity graduate. She did so as an "independent" and does not take the Labour whip on issues. She first ran in 1997 and again in 2002, unsuccessfully on both occasions. She was elected on her third attempt in 2007.

The Seanad appealed to Ivana because "there's much more space to express radical views (than the Dáil) and give voice to viewpoints that might not be heard otherwise," she says.

There have been some wonderful senators over the years who have made really great use of the platform they have in the Seanad and have made worthwhile contributions, she believes. She mentions people like Senator Gordon Wilson, the peace campaigner whose

daughter Marie was killed in the Enniskillen Remembrance Day Bombing in 1987 and who was appointed to the Seanad by the Taoiseach.

Ivana also mentions Senators Mary Robinson, for her contraceptive legislation in the 1970s, David Norris, a powerful voice for gay rights, and Mary Henry, a strong campaigner.

She is not blind to its faults, and believes that the Seanad needs reform, citing the fact that she believes it is wrong that none of the new universities, like University of Limerick (UL) or Dublin City University (DCU) or the Institutes of Technology have an opportunity to elect senators.

A total of six senators are elected to represent universities. Three each from the National University of Ireland and University of Dublin (Trinity). There are also 43 elected senators and a further 11 senators who are nominated by the Taoiseach.

Because of her two Seanad campaigns, she was asked to run for the Labour Party in the European Elections in 2004 with Proinsias de Rossa, who retained his seat (he was already an MEP). She got a very strong vote and found that it was a very positive experience. "But it was a mammoth task," she says. "There are one million people across Dublin. I tried to travel to every part of Dublin to speak at public meetings and do as much knocking on doors as possible. I had no kids then so it was easier but it was still a daunting task." On a

more frivolous note she says that Liz O'Donnell, the former Progressive Democrat TD for Dublin South, told her at one stage that an election was a great way of getting fit!

Ivana was bitten by the bug like never before for representational politics. "I would love to be elected to a position where I could effect real change. There are very few politicians who would not want that," she says. In 2009, she stood for election as a Labour Party candidate in the bye-election for Tony Gregory's seat in Dublin.

She has written, co-authored and contributed to about a dozen books. The Law School in Trinity has a very research-active culture, she says, and colleagues nurture research and encourage publication.

She is particularly proud of some of the collaborative work that she has done, and hopes that it might have improved levels of knowledge and awareness in specific areas. With a number of colleagues, she did the first survey of lawyers to see if there was gender discrimination in the legal profession. The research was done in 2003. She found that discrimination exists, and there is sexual harassment at the bar.

The discrimination is not overt, although one woman did describe a judge, who told her, in court, "you're far too pretty to be taking this action my dear".

Women feel excluded from social networks like golf outings. You cannot really further your career if you are a solicitor in a small town and you are excluded from

these functions. There was also a real problem when
female solicitors had children – that was when their
carer progression slowed completely. "Two-thirds of
law students nationally are women. At the entry level to
both solicitor and barrister professions, women are
equal to, if not greater in number, than men. But, at the
top levels, they are still vastly outnumbered by men. We
made recommendations for reform in solicitors' firms
and, as a result, the Law Society now recommends that
they pay full salary for their employees who go on ma-
ternity leave," she says. Other research she has done on
rape led to some changes in the law.

She lives with her partner, Alan, and their two
daughters aged one and three years. "They're great.
We're delighted with them. I relax with the girls at
home. We live in the city centre so there's no commut-
ing time. We have a good quality of life. Both of us have
family in Dublin and lots of back-up. We try to get away
as a family when we can. It's important to spend time
during the day just hanging out. It's harder to do it at
home in Dublin because inevitably calls come in and, in
politics, it's not so easy to get time off," she says.

As a mother, she is proud of having the two girls –
"a relatively new experience for me". Politically, she is
proud to have been elected to the Seanad in 2007, and
having succeeded Mary Henry. As a feminist, she is
proud of achieving change for rape victims through re-
search in 1998, and a change in the law in 2001.

Her wish for the future is simple – that she would continue to combine busy work life with busy home life. It is a daily challenge that she is finding very enjoyable at present.

As a student, barrister, lecturer, author, researcher, senator, media commentator and feminist, Ivana Bacik never demurs from putting her point of view. Her argumentative streak has served her well across a broad range of disciplines.

Maree Morrissey

Maree Morrissey is a trained classical pianist. An all-Ireland and Commonwealth high jump champion, she previously worked as a senior layout artist with the Walt Disney Studios in Paris. She currently publishes Irish Entrepreneur *Magazine, the highest circulation business magazine in Ireland.*

"How on earth do you become an entrepreneur?"

BY 2003, MAREE MORRISSEY WAS an accomplished classical pianist. She had established a career as a performer, working with some of the best known names in the music business. She had made enough money from selling ads to fund her house and her car, and she was ready for her next move.

Maree wanted to open a music school for children with mental and physical disabilities. She had always enjoyed working with children, and really wanted to teach them through music therapy and art therapy.

"There was a huge demand for the school but I just couldn't raise the money," she says. She approached a bank and two county enterprise boards, but no one would lend her the money. Her proposal didn't fit any of the established "categories" for the enterprise boards and the bank manager just seemed to have a problem lending money to a woman!

Utterly exasperated, she set about finding out how on earth you become an entrepreneur in Ireland. In the process, and quite by accident, she became one of Ireland's leading entrepreneurs, launched a new business magazine which has the highest sales and readership figures in its category, and still plans to open her music school almost a decade after she first sought funding. This woman doesn't know how to take "no" for an answer!

Maree Morrissey is a Kildare woman through and through. "We were hicks," she says, laughing. "The closest I got to Dublin as a child was being born in Holles Street hospital". She has two sisters and three brothers and, she says, is "the middle child who got forgotten". You cannot imagine anyone forgetting Maree Morrissey.

She originally lived in Knox's Corner in Brownstown on the edge of the Curragh until she was about five

years old. The family then moved to a new estate called Suncroft in Monasterevin, then a tiny little country village about five miles from the Curragh and 40 miles from Dublin.

The family didn't have much money but she says they managed well. Her father was stationed at the Curragh Camp. It had been used as a military detention centre for civil war prisoners originally, and later in the 1950s members, and suspected members, of the Irish Republican Army were kept there. "We were brought up sleeping in prison blankets. We all had a prison number," she says. "It was stamped on the blankets we slept in! We were all numbered instead of named!"

Maree always had a great interest in music and studied classical piano and guitar from an early age. Her father and her aunt originally taught her piano and she then moved on to formal piano lessons. It cost £1.50 for a half-hour lesson, and she used to get the early bus into school so that she could have a lesson before school. She also went down at lunch-hour for a second lesson. She had her diploma by the time she was 16 years old. After she finished her Leaving Cert she continued to study – by distance learning – eventually doing a masters with the Royal Irish Academy many, many years later.

Music was in the family blood. Her father was a drummer with Joe Dolan's band, and he had played with Thin Lizzy before Brian Downey joined. His father,

Maree's grandfather, played piano with RTE, and both her father and to a greater extent his sister were accomplished pianists.

Maree never wanted to be a music teacher – her eyes were always firmly fixed on performing. She had a little studio in her bedroom with electric keyboard and microphone. Her brother and his electric guitar used to complete the sound. She loves to play – and she loves to take the limelight. When she was growing up, she wanted to be a famous singer. Her role model was Stevie Nix, singer-songwriter and lead vocalist with Fleetwood Mac, the band which sold 33 million copies of their *Rumours* album in 1977. *Rumours* topped the charts the year that Maree moved to Suncroft. She was addicted from then on. "I used to sing into the hairbrush," she says

Ten years later, Maree joined a band from their local estate. The first gig that they played was in the parish church. "The poor priest nearly fell out of his standing. We arrived in with a drum kit and an electric guitar and a piano keyboard that my father got for me. I thought this was great. We were giving it yards! I was like Ray Manzarek out of the Doors." (Ray was the keyboardist with the American rock band.) It wasn't long before the PP realised that this was not what he had in mind for his church. It was the only gig they ever played in that particular venue.

That same year, she sat her Leaving Certificate exams. Maree was only 15 years old. Derek Davis announced the "Battle of the Bands" competition on RTE's popular afternoon television show *Live at 3* and she was off and running. Her band entered the competition. She played keyboards and did backing vocals. The band already had a lead singer who was talented and beautiful. "I wanted her out of that job!" says Maree. Not only did they enter the competition – they made it through to the finals and won.

For quite a few years afterwards, Maree concentrated on music as a career. She performed with a number of bands, recorded with Van Morrison and played backing piano for Tori Amos.

When she was 30 years old, she felt that the time was right for her to open a music school for children with physical and mental disabilities. So she set about finding funding for her new venture.

There are 34 County and City Enterprise Boards in Ireland. She approached two of them. Enterprise Boards are responsible for supporting the start-up and development of local businesses in Ireland. However, Maree didn't fit into any of the categories that the enterprise board were seeking to help. Her music school was never going to become a global business, she didn't have the potential to employ more than 10 people and she wouldn't be exporting, so the Enterprise Boards wouldn't help her.

She also approached a bank. The bank manager (she would not name the bank) was decidedly strange. "If you'd come here a few days earlier there was a woman in my job and you might have got lucky and she might have given you a few bob," he told her. Whatever hope he thought she had of securing a loan from the female bank manager, he left her in no doubt that he would not be giving her any funding. "I was gutted inside," she said.

Utterly exasperated, she decided to go back to square one and figure out how she could become an entrepreneur. She started looking for some books to read about marketing, recruitment, putting a business plan together and inspirational entrepreneurs. She found the book *Starting a Business in Ireland* by Brian O'Kane in Oak Tree Press. (The book is now in its fourth edition.) "It is excellent," she says, "really excellent – but it was like going back to school." She found it to be academic and full of text and she really wanted something more colourful and inspirational.

"A music school is not your everyday business set-up. I wanted something that had nice pictures and would tell me stories about people who would inspire me. I couldn't find it, and that was when I decided, I'm going to set up a magazine," she says. *Irish Entrepreneur* magazine hit the shelves in 2003.

This is a woman who will not be easily distracted from her goal. Unknown to herself, she had been build-

ing her entrepreneurial and publishing skills all her life. Determination and the need to win had been bred into her as a child.

Shortly after they moved to Suncroft in 1978, her father set up a running club for the estate. He was the driving force behind it. He encouraged his children to participate and expected them to win. All six siblings competed with the club.

The club members competed in the all-Ireland and Commonwealth championships, and Maree won the high jump almost every year (her younger brother was also a regular medal winner).

They went to running competitions every Saturday and Sunday, and each Thursday morning. They ran cross-country races barefoot because they couldn't afford spikes. It never bothered them. "The best thing I ever did in my life was that – training, running, winning. It was better than school, better than anything," she says. Maree started running when she was five years old and stayed with it till she was about 17 when she competed in the junior women's championships. "It was tough going but great fun," she says, "and you were always a hero when you got into school and that fed you again for the next week. There was great community spirit."

"You know that saying – behind every man there's a great woman?" she asks. The woman was her mother. Her mother kept it all together and travelled every-

where with them. She was the one who made sure that everyone was organised to be away for the weekends. She made the sandwiches, brought the blankets and towels, poured the flask of oxtail soup, and made sure they were all tucked up in bed when they got home and ready for the next day in school.

In later years, it "didn't work out for them", and her parents divorced, but in her early years her parents were a formidable double-act.

When the divorce happened, all of the family gave up sports and fitness. Everyone deals with issues like this in a different way. Maree says that she became a "right oul fatty" rising to about 15.5 stone. It was her way of coping. She lost it all again when she was 19-20 years old.

Maree had also shown early signs of her ability to manage a business. When she was 16, her mother and father opened a "Pound Shop" in Monasterevin. She was at a loose end after her Leaving Cert, playing with bands by night, but not doing anything during the day. She decided to run the shop for her mother and earned the princely sum of £50 per week (the average industrial wage in the mid-1980s was £171.48 per week). On Saturdays, she taught children art, guitar and piano. She made more money on Saturdays than she made for her week's work in the shop. Add to that the fact that she was making money from the band and you can see just how industrious this 16 year old really was!

If you're going to eventually publish a magazine, good layout and design skills wouldn't go astray! Music had always been a creative outlet for her, but Maree was also very artistic. She had always been good at art, regularly wining the Credit Union and Texaco competitions. Her mother encouraged her to take up some study in this area. She loved drawing and decided that she wanted to do the animation course at Ballyfermot Senior College in 1989.

The course was first introduced in 1978 with the arrival of the Sullivan Bluth animation studios in Dublin. They had moved most of their staff from the USA to Ireland during production of the studio's second feature, *The Land Before Time*, and were heavily involved in setting up the animation course at Ballyfermot to train new artists.

Unfortunately, during the making of *All Dogs Go to Heaven* in 1989 John Pomeroy, one of the founding members of the studio, returned to the USA with most of the remaining US staff. It was the end of Sullivan Bluth as employers in Ireland but not the end of the animation course which continues to this day.

Competition for this course was intense. It attracted interest from all over Europe and there were only 15 places available. In the end, it was mainly Italians, Finns and French on the course. Only two places went to Irish students – and Maree was one of them. She hated it. She spent her time drawing the same thing

over and over again and it didn't suit her at all. "But I fell on my feet there. One of the masters from Disney came over to look at the work of the class." He spotted her talent instantly. She was great at layouts which she actually loved doing.

She won a scholarship and headed to Disney in Paris. She worked as a senior layout artist for some of the world's movie blockbusters. She is really proud of her work on the Disney movie *The Hunchback of Notre Dame* which has 11 of her drawings. The movie, which was released in June 1996 (these animated films can be, literally, years in production), was nominated for an Oscar and won seven awards. Kevin Kline and Demi Moore were among its most famous "voices".

However, Maree tired of the work and longed to come back to Ireland. She headed for home. Unfortunately, "the whole country was a mess and artists and musicians were just like white witches from hell". There was no work for them and most were signing on the dole.

She spotted an ad in the *Evening Herald* which was looking for someone who was motivated, persistent and a good communicator. "Heck – I can do that," she thought, so she applied. The job was selling ads to farmers for a chicken magazine. They told her it was easy. Just contact farmers and ask them to wish their customers a happy Christmas. The ads cost £200 each and they offered to pay her 50 per cent of the advertis-

ing sales that she generated. This provided Maree with an opportunity to enter the world of media and develop crucial "sales" skills.

She was really good at it. She would spend all day on the phone selling, then visit the farmers that she hadn't been able to "snag" earlier in the day. "Before I knew it I was down in Laois in my wellies selling ads to farmers," she says. She arranged trips around the country to get farmers to sign up to their ads. She found it easy to sell and made plenty of money.

For six years, she worked for a number of different trade magazines, always selling ads. She was good at it but never liked it. When she finally left, she tried to figure out why she disliked it so much. "I realised that I didn't like the quality of the products, I didn't believe the circulation figures and I wouldn't buy an ad in some of those magazines myself!" It was time to move on.

She was now 30 years old. She had acquired a house and a car and was looking for a new challenge. She had set about opening her music school but couldn't raise any funding. When she set about trying to find out how to become an entrepreneur, she found a niche in the market and decided to got for it. Maree Morrissey became a publisher and introduced a new magazine to the Irish news shelves – *Irish Entrepreneur* was born.

Despite all the skills she had acquired along the way, the launch – and the first few editions – were not without their trials and tribulations.

She put Jim Kerr on the cover of the first edition. It caught the public imagination. Jim Kerr is a Scottish musician and singer-songwriter with the band Simple Minds. What was a musician doing on the front of a business entrepreneurs' magazine? It sold out.

She started the business with her own money which was a very brave move. She had bought a house in Kilcullen which she sold for the sum of £18,000, and she used the money to help her buy a house in Wexford for £100,000 "I qualified for a mortgage – you don't want to know how I qualified for that – there was a lot of creative accounting!" she says.

She used £10,000 of the money for a deposit, put another £3,000 into a DIY kitchen and with the remaining £5,000 started her business.

The house was a run-down dormer bungalow at the end of a muddy boreen. This was also to be her office. She bought a second-hand computer and ran the wiring from one side of the room to the other using selloptape to keep it in place. And she decided that she needed to employ a sales executive to sell ads in the magazine.

She placed ads in the local *Wexford Echo* newspaper and got a great response. On the day of the interviews, she asked her cousin to be there to make tea and offer biscuits to the applicants. She changed the look of the sitting room to a waiting room and began interviewing.

She offered the job to "a lovely man who was a butcher. He was upfront and honest and hardworking

and willing to do the job and I thought – he's not going to be afraid. He's a bit like me. I'm going to give him the chance."

On his first day, he sat at his desk (which herself and her cousin had, quite literally, put together the night before) and it collapsed. "Right so," he said, "I'll go on, now, and get a hammer and nails." They never saw him again. She decided to stick with selling the ads herself for another while.

For the second issue, she took some advice from James Morrissey, one of the founder directors of the *Sunday Business Post* who was working with Fleishman Hillard, the international PR consultancy. He recommended that she should make the front cover more Irish and he also told her that she needed a woman. He suggested Moya Doherty, producer and co-founder of the internationally acclaimed Riverdance theatre phenomenon. "Women were never seen as entrepreneurs. We were never awarded that honour," she says.

She took his advice and put Moya on the front cover. But the designer and printer messed up. "The wrong cover went on, basically. These things happen," she says, "but I had lost a fortune on the magazine already and I was looking at just shutting it down completely".

As luck would have it, she met Bill Cullen. He was an admirer of the magazine and asked her how it was going. "Naturally, I talked it up," she said. "It's flying I told him. I'll be living in Dublin 4 before you know it!"

He was bringing out his book, *It's a Long Way from Penny Apples*, and wanted to appear on the front cover. "I told him that I'd love to have him on the cover, but he'd have to buy the inside front cover (a full-page advertisement)." He did. Bill was chairman of the Glencullen Group which owned the Renault car distribution franchise at the time. He bought the ad for Renault "and I made him pay upfront," says Maree. That £4,000 kick-started the business again.

Bill Cullen also launched the next edition for her in Dobbins Bistro, the Dublin restaurant favoured by everyone from media types to captains of industry. John O'Byrne, the owner, offered to help her. "You just come up here and sit beside me in the restaurant, and I'll introduce you to everyone," he said. She sat beside him for four weeks. "John knew them all. I met Camilla Parker Bowles, Prince Charles – you name it! He was plastered in the corner, and I was equally as plastered, and it was great. And the business got back up on its feet again thanks to Dobbins and Bill Cullen."

David McWilliams (the economist) spoke at the launch and Mary Harney, then Minister for Enterprise and Employment, was also there. It was a great hooley, "the place was humming". No one ever wrote about entrepreneurs in Ireland; it was a word that wasn't used at the time. "In fact," says Maree, "there was a stigma attached to the word entrepreneur. Many of the people I

interviewed said, don't call me an entrepreneur, just call me a business person."

Irish Entrepreneur is now the largest circulation business magazine in Ireland. Earlier this year (2009) she did a deal with the *Irish Times* which saw 150,000 copies of the magazine distributed with the newspaper. Nothing like this had ever been done before on such a grand scale. Newspapers don't generally distribute independently produced magazines, but Maree had negotiated it, the *Irish Times* included it, and now she has a couple of other papers looking for the same deal.

The woman has an indomitable spirit. She brought the Naked Cowboy to Ireland in January 2009 to promote the *Irish Entrepreneur* "You can do anything" campaign. Robert John Burck, better known as the Naked Cowboy, is an American busker whose patch is on New York City's Times Square. He wears only cowboy boots, a hat, and underwear, with a guitar strategically placed to give the illusion of nudity.

He certainly attracted the level of attention that she was seeking for the magazine. "I fell for him – head over heels – who wouldn't?" she asks. Interestingly, while he was here, she discovered that he didn't have a European agent. He does now! That woman doesn't let the grass grow under her feet. "He has great market potential in Europe – and I've gotten him a few gigs already," she says.

There are quite a number of women in publishing in Ireland. Norah Casey in Harmonia, Rosemary Delaney in Women Mean Business and Karen Hesse, one of the first women in magazine publishing, with Dyflin. Maree believes that women are attracted to it because "it's one of those service-based sectors. It's either PR or publishing. They do go hand in hand. And it's the journalism side. A lot of women are journalists," she says. She has never felt the lack of any journalistic background. "To be a publisher, the least thing you need is journalism and the best asset you need to have is sales. You must be able to sell. Forget running the business – the business will run itself if you can sell. It's a dog eat dog business. You have to be able to sell and close. I'm doing it every day of the week."

And she sees huge opportunities outside Ireland. She has two other magazines in Dubai where there are no female publishers. She lived there for a while and plans to do so again in the future. The differences in cost base and profit are phenomenal. "They pay on average €30,000 for a page ad. We would like to get €25,000 (in Ireland) but, with a distribution of 150,000 we would get €8,000-10,000 at best for a page. I was printing a magazine in Dubai and I was able to print it for 52 per cent cheaper than I would print it in Ireland, and that included transporting it from Dubai, and I'd get it back quicker to Ireland."

Six years after the launch, she is now hoping to sell *Irish Entrepreneur* magazine – and she's had a few offers already.

Along the way, she became a mother. Maree and her partner David have a three-year old son, Josh. "We love him. Poor oul Josh has Cerebral Palsy – its mild, mind you, but there's a huge thing – you routine yourself. You're like a robot. You go to bed thinking about it and you get up thinking about it."

"I'm going to sell out of the magazine – that was always the game plan – and I want to go back and set up my music school. And now with Josh, here's a child I've been given, a child with cerebral palsy, a gift, who would have thought it? I adore him. I would love to set up my music therapy school. I do therapy with Josh. I teach him music and his right hand is great because of it. I work mostly with his right hand and leg, that's what he's mostly affected with. That's my aim to sell out, make my millions – hopefully! – and take Josh under my wing."

She works late in to the night and doesn't relax. "Women - Mna na hEireann. You just get on with it, don't you?" she says. "I mean, you're lying in bed for five minutes at the start of the day and the day is mapped out and planned, and by the time your two feet hit the floor you are gone, the shower just happens, you don't know you've even been in it, the hair is done and the next thing before you know it you've a child under

your arms and you're out the door with the keys in your hand."

She also wants to set up a PETO Clinic in Ireland. The PETO Institute for Motor Disordered Children, better known as the PETO Clinic, in Budapest, Hungary, provides unique treatments to children with Cerebral Palsy and other ailments.

As she is leaving at the end of our interview, I remember that I haven't even asked her about her television debut on RTE's *The Fund* where she grilled potential Irish entrepreneurs. "Oh and I never told you about my new television show," she replies. She has begun filming a new series about entrepreneurs. She had just completed her first week working with Sir Alan Sugar (learning how to be an entrepreneur and close big deals) and was looking forward to her next week with Richard Branson.

Thank heavens Maree Morrissey isn't going to disappear off our radar anytime in the near future. She is a powerhouse of a woman. Long may her entrepreneurial spirit thrive!

Mary O'Rourke TD

Mary O'Rourke is one of Ireland's most senior politicians. She has twice served as Minister of State: for Trade and Marketing (1992-93) and for Labour Affairs (1993-94). She held three senior ministerial portfolios as Minister for Education (1987-91); Minister for Health (1991-92), and Minster for Public Enterprise and Transport (1997-2002). She was Leader of Seanad Éireann for five years (2002–07). She is a sister of the late Brian Lenihan TD, and aunt of Minister of State Conor Lenihan and Finance Minister Brian Lenihan Jnr TD.

"Vox populi, the voice of the people, is very important."

MARY O'ROURKE WAS BORN into a political family, in Athlone, Co. Westmeath. Athlone is generally thought of as the "centre of Ireland". It is the principle

crossing point on the Shannon River which divides the east of the country from the west. Athlone is 130 kilometres from Dublin to the east, and 95 kilometres from Galway to the west. Because of its location, and its military importance since the 1600s, it has always been a thriving commercial centre.

Mary's father, P.J. (Patrick) Lenihan, was "Mr. Fianna Fáil" in Athlone. He was chairman of the Town Council, chairman of the County Council and president of the local Chamber of Commerce. "He was a big wheel in a small town," says Mary.

Mary was educated in St. Peter's, Athlone and the Loreto Convent, Bray, Co. Wicklow. After that, she went to University College Dublin (UCD) to study for a Bachelor of Arts (BA) degree.

Mary's father had been a revenue inspector in the civil service until Sean Lemass poached him to run General Textiles, or Gentex. The factory employed almost 1,000 people at its peak. It ran seven days a week, 24 hours a day, in eight-hour shifts. It was a very successful cotton mill. The cotton arrived in huge bales and moved on to the spinning shed, then to the weaving shed and finally to the BDF – the bleaching, drying and finishing sheds. The company was an institution in the town for nearly 50 years and many people remember ringing in the New Year, each year, to the sound of the Gentex horn.

It was a very political household. The house was always full of talk of politics, but her father hadn't time then to run for public office. He was too busy running General Textiles. He had run for election once, in the 1950s, "but not very seriously," says Mary. However, by 1965 he had more or less retired from business life. He had bought the Hodson Bay Hotel. The family were living there, and he and his wife were running it as a small, family business. He had more time, and decided to pursue his interest in national politics.

The Hodson Bay Hotel had been a private house, known locally as the "Queen Anne Mansion". It had belonged to the Gunning family, whose three daughters were known as "the beautiful Gunning sisters". Their portrait, painted by Sir Joshua Reynolds, hangs in the National Gallery of Ireland on Merrion Square.

The house is beautifully situated on the shores of Lough Rea about five kilometres outside of Athlone town. When the family moved in, it was a three-storey house with 12 bedrooms and a ballroom for weddings and functions. (It is now a 182-bedroomed, luxury four-star hotel.)

Mary returned from Dublin with her degree and no other plans. By that stage, "Enda O'Rourke had loomed in my life and I wanted to be back in Athlone, with him, in his arms, morning, noon and night – that's all I wanted," she says.

They first met when she was 18 years old and he was 20. They broke up once or twice and he dated other girls and she dated other guys. "But we'd hone back to one another," says Mary. "We knew really that we were for one another."

Mary was 20 years old. Her sister, Anne, who was five years older, had trained in hotel management at the college in Cathal Brugha Street, and had been running the hotel for their father. Now, she was getting married and heading off to Cork to start a new life with her husband. Mary's father suggested to her that she might stay in Athlone for a few years and help run the hotel. That suited her down to the ground.

She was 22 and Enda was 24 years old when they got married. It was considered very young then. "I remember my mother and father having fits about it and saying, 'aw, listen here, you're far too young' but what did I know about anything – nothing – but you're as well off to go in, feet first and I did," she says.

Mary's brother Brian was actually the first member of the family to be elected. He was returned as a TD for Roscommon-Leitrim in 1961. His father, P.J. Lenihan, followed him into the Dáil in 1965 when he was elected for Longford-Westmeath.

The following year, at the age of 29, Mary saw an advertisement in the paper. St. Patrick's College, Maynooth were offering a Higher Diploma in Education. Grattan's Parliament had passed an Act in 1795,

creating Maynooth University "for the better education of persons professing the popish or Roman Catholic religion". It had become not only Ireland's national seminary, but the largest seminary in the world at one time.

In 1966, it opened its doors to lay students for the first time. Mary wrote off and was accepted. There were four people from Athlone taking the H. Dip in Maynooth – a nun, a brother, another man and herself. They did four nights a week in college. Maynooth isn't far from Athlone, but the four of them took it in turns to take the car, so everyone only drove the one night.

Mary found a nice woman to mind her son Feargal, who was two-and-a-half years old. He took great pleasure in telling anyone who would listen that "my mammy goin-a-gool, she goin-a-gool". After she graduated, Mary started teaching.

Her father ran for a second term in the Dáil in the 1969 election and was re-elected, but died a year later in 1970. He was 64 years old, considered "a fair age" at the time, but a young man by today's standards.

The Fianna Fáil party in Athlone wanted Mary to run for her father's seat. She had been an active member for years, and had joined the youth wing of the party, called Macra Fáil, "the sons of Fail", as a young teenager. Macra Fáil were "junior dogsbodies" says Mary, "used for dropping flyers and letters and canvassing".

At the time of her father's death, Mary was secretary of the Comhairle Ceantair in Athlone, and was married

with two young sons. Aengus was just five months old and the eldest son, Feargal, was five years. She didn't run and she never regretted it.

"You can't have it all," she says. "Women know that. There are no superwomen. I remember Shirley Conran wrote a book a few years ago – 'I'm too busy to stuff a mushroom' – or something like that." (The reference is from Conran's book *Superwoman* which was published in 1975.)

The children were too young when her father died and she also felt that she needed to get a taste of local life. And she did. She was first elected to Athlone Urban District Council in 1974, and from 1979 to 1987 served as an elected representative on Westmeath County Council. "Let me tell you, if you've snarled with the town clerk or the town engineer or the county manager, you're fit for most things in life," she says.

Being a woman in politics takes a huge amount of organisation, co-ordination and forward planning. Mary spent six months in the Seanad before she won her first Dáil seat in 1982. It was great training for her.

"I would put a chicken in the oven – this was before there were timers on ovens. It took two hours to go to Dublin. I'd put in the chicken and I'd go to Dublin. Then I would ring back home. Enda would come in at lunch-time. 'Did you turn off the oven? Did you take out the chicken?' I'd ask. 'Oh, it looks grand,' he'd say, and the

kids would come home and muscle into the chicken. So, we had chicken for those six months," she says.

She was elected to the Dáil in 1982 and was immediately appointed Fianna Fáil frontbench spokesperson on Education.

"I often thought of that very nice woman who was married to Alexis Fitzgerald – Mary Flaherty. She was a woman deputy at that time and she used to come in and out of the Dáil on a bicycle from her home in Rathmines and she had four young boys. I'm sure she had very good competent home help but she was able to get home to them during the day and then get home again in the evening." That must have been a huge advantage, she thinks.

There were very few women TDs when she came into politics, but Mary is quick to name the ones that she thought were very good. "Monica Barnes was there. Maire Geoghegan-Quinn, Myra Barry – she left it after a few years, she had an unhappy personal situation. Looking back there were some excellent people. Gemma Hussey was there. I shadowed her in education, she was the Minister for Education," she says.

The women she named, like herself, are all strong women. "It's the most terrible injustice going," she says. "People say she's not bad for a woman, is she? But he's just a nice bloke, strong bloke, good bloke, blah, blah, blah."

And then there are the other qualities which are needed in politics. "If a woman is affirmative and positive she's 'bossy and aggressive', that's what they'll say, so you have to fight all those things. A man is *dynaaaamic*. There are no dynamic women, at least it appears to me there are not because we never get that adjective!" she says.

In 1987, Mary and her brother Brian became the first brother and sister in the history of Ireland to serve in the same cabinet when they were both appointed to ministries by Taoiseach Charles Haughey. Brian became Minister for Foreign Affairs and Mary O'Rourke was appointed Minister for Education, a position she held until 1991.

"People say that doctors should not be Minister for Health and teachers should not be Minister for Education. I found it an advantage because I knew the lingo," she says. "I knew what they were talking about. I knew that PTR was pupil teacher ratio, and I knew about curriculum and subjects." It meant that she had a head start, she felt. "Certainly it was an advantage when I would meet the unions. They would know that I knew what I was talking about," she says.

Education was definitely her favourite ministry. She felt that she was doing things which would be useful for people – doing things for womankind and mankind which would have an impact on future generations.

She has always had a mastery of her brief, no matter what ministry she held. "I'm very curious," she says. "I've retained that sense of curiosity always. I want to know everything about everything and I would bring home the files to the flat in Dublin at night and really delve into them."

She loved her time as Minister for Health, but she was only in that ministry a very short while, from November 1991 until February 1992. "If you remember, Albert came in on the fourteenth of February, St. Valentines Day, and he massacred – the St. Valentines Day massacre – eight full ministers and fourteen junior ministers," she says. She lost her position as Minister for Health.

"I wailed that time after Albert," she says "Enda was with me in Dublin and I put the duvet up over my head and I wept – big salty tears – and had lots of gin as well. And then I came to and I moved on," she says. By comparison with what happened to her later in life it was "so little – so very little," she says.

"I happily went into a junior ministerial post and loved it," she says. She was appointed Minister of State for Trade and Marketing (1992–93). Des O'Malley was the senior minister. He had been a Fianna Fáil deputy originally, but had left to form a new party, the Progressive Democrats, in 1985. "He left me sweetly alone," says Mary, so she got on with devolved authority and

consumer affairs "which was great". She became Minister of State for Labour Affairs in 1993.

In 1994, Bertie Ahern became leader of Fianna Fáil and appointed her Deputy Leader. The following year, 1995, she became frontbench spokesperson on Enterprise and Employment and, in 1997, when the government changed, she became Minister for Public Enterprise and Transport.

She was Minister for Public Enterprise when she lost Enda in January 2001. It was a great shock to her, and eight years later, she still has not fully recovered from it. They were a very close couple. "I loved him and he loved me," she says, matter-of-factly.

His death was as sudden as it was unexpected. "He'd had a big heart operation the year before but he had recovered massively, terrifically, and he was in good form. It was the thirty-first of January and it was a fine bright sunny day, high sky, you know one of those nice late winter days when you think you can see spring coming," says Mary. She had been out in the country, presenting prizes at a point-to-point. She had returned home and they were chatting. Enda was in great form.

It was 5.00 o'clock on a Sunday evening. "He went to the window of the living room and said, 'look at the stretch of the evening will you? Isn't it wonderful? There's a new spring and summer coming'. I said 'yes' and, within an hour, he fell on the floor. It was awful. Even now – the rawness of it never left me," she says.

Enda died in January 2001 and in May 2002 Mary lost her Dáil seat. "Now, first of all, I think the world and his mother knows that I think Bertie did me, he shafted me," she says. "I'm not going to go back into that now, that's over, I said it and got it out of my system. But, he shafted me because they laid out what area I could go into and couldn't go into and all the rest," she adds.

It was only 16 months since Enda's death and she will still grief-stricken, even though she didn't recognise it at the time. Enda had always been her eyes and ears locally, and she missed that too.

"Enda had been the guy who'd gone up to the local pub and gone to the local meetings and alerted me to everything that was going on that I should know about, and he did all that for me and therefore I missed him as well," she says.

She lost her Dáil seat to Donie Cassidy. Donie was well-known locally. He was a native of Castlepollard, Co. Westmeath and had been a senator since 1982. There was intense rivalry between the two party colleagues.

Mary lost her seat, and Bertie Ahern appointed her to the Seanad as one of the Taoiseach's eleven nominees, and made her Leader of the House (2002–07).

"I loved that five years," says Mary. "I sailed away and nobody told me what to say or do. There was a very good woman clerk of the Seanad, Deirdre Lane, she still

is there. She showed me the ropes and away I went. And it was a very satisfying job."

She firmly believes in the importance of the Seanad as an arm of government, and honestly thinks that it is not held in the high regard that it should be.

But, for those five years, she never lost sight of the Dáil seat that she had lost, or the desire to win it back. "I was the only Oireachtas member in Athlone and in a way the people still looked to me to be their gal in Dublin, and still kept coming to me and I kept dealing with them and wanting to help them," she says.

"You see, *vox populi* is important. The voice of the people," she says.

She won back her Dáil seat in 2007. "I'm so satisfied at having got back my seat," she says. "Not in a vindictive way – saying, 'aw yea, she's delighted she got rid of Donie Cassidy' – no that's not it. I'm just satisfied that I got back the seat that I had. There's nothing to beat democracy. It's the people's voice coming through. And the constituency is Longford-Westmeath now, which really suits me. Long ago it was Longford-Westmeath, but it changed en route to being just Westmeath. Now we're back to it being Longford-Westmeath. My father had always a very great following in Longford and, they bided the years, and their sons and daughters voted for me the last time round," she says.

And she loves her new found freedom as a backbencher. "For the first time in my life, I can actually say

what I want to say. Now, being in office never stopped me saying what I wanted to say but I'm freer again. Free to represent the people in a very full way. Free to be their voice and I like being there," she says

Mary makes friends and keeps them for years. "I like Aine Kitt. I like her very much. She and I have a great history together," says Mary. Aine Brady, nee Kitt, was elected to the Dáil for the first time in 2007. "Many, many years ago she was teaching outside Ballinasloe, where she lived, her home place. She, and my brother Paddy Lenihan (who is still alive, thank God) and myself were members of the national executive. Once a month we would leave our cars in the yard of the old Prince of Wales Hotel (in Athlone) and share a car up to Dublin to our national executive and home."

"As you're coming out of Dublin, near the entrance to the Phoenix Park, there's a Caffola's or some of those there. We'd buy three big bags of chips and the smell of the vinegar! And we'd munch and chat on the way home. They were fun days. I like Aine Kitt. We share a past and we're very happy to share a present as well," she adds.

She would encourage more women to enter politics, but would also warn them that "it's one of those things where you are forever chasing your tail," she says. "I often thought I'd love a wife," says Mary, "because she'd bring my clothes to the cleaners, to the menders, take up the hem, put down the hem, she'd tell me when my

hairdressing appointment was, when I needed to get a facial if I did, when to buy clothes. You've to do all that as well," she says.

And any woman going into politics must be financially independent, says Mary. "First of all, she'd better have a job. She'd better be earning money. If she's single, fine, she'd need to be in a job anyway. If she's married or partnered or whatever she'd need a job because she might feel, to use her partner's money for her political advancement, might be taking it from the family. So I always say to women, get yourself a good paying job. I was a teacher. So, you have to get yourself a car, get yourself tarted up, buy the gear, buy your rounds in pubs, go to meetings – all that, and that means money," she says.

Mind you, she doesn't think that more women will come into politics in future years, "based on what happened to myself," she says. "When I got my opportunity when my father died in 1970 I felt that I should really be, for those young years, with the children. I couldn't see myself off to Dublin and leaving a four year old and a five month old behind me, no matter what nurses, nannies or housekeepers I got in," she said.

"The nurturing thing is in a woman. That's your hormones. That's what you have your bodily functions for, as a young girl, and it all builds up to, if you have a partner, to having children and then the nurturing thing kicks in again. And even if you didn't marry,

there's always perhaps aged parents or an aged aunt to be looked after, and it's usually the woman who does that. How are there going to be more and more women (in politics) when more and more women have that other urge as well – the urge to be a woman?" she asks.

In June 2009, a new generation of O'Rourke's entered politics. Her son Aengus stood for the local elections and was elected in Athlone on his first outing. He secured 487 first preference votes, the highest number of first preferences ever recorded for a new candidate, and is now a councillor on Athlone Town Council.

"He's President of the Chamber of Commerce in Athlone right now (2009) and a real good man," says Mary. The chamber represents 250 businesses from sole traders to large multinationals. "He bought the franchise of Snap Printing in the midlands which covers four locations – Athlone, Mullingar, Tullamore and Roscommon. At the moment he's in Athlone and Mullingar and later on when the economy picks up he'll be in Tullamore and Roscommon. So he's getting on well," she says.

It was logical for him to follow in her footsteps. "He's living in Athlone, his wife and children are there, his business is there, so he's best situated to run there," says Mary.

Feargal, her other son, is a partner at PricewaterhouseCoopers in Dublin. He is a member of the Commission on Taxation, a fellow the Institute of Chartered

Accountants and an associate of the Irish Taxation In-
stitute. "He wasn't going to uproot his job and his wife
and his children and his home and move down (to Ath-
lone) even to satisfy mother, no," she says.

She relaxes by "talking, reading and going out with
friends", she says. "I've friends in Dublin and friends in
Athlone. Every Saturday night four of us go out, we
have a meal and a glass of wine and good chat. In Dub-
lin I might go to the theatre or I might go to a fashion
show or I might just go out for a glass of wine."

She reads voraciously. Her eldest son, Feargal, gave
her five books for Christmas 2008. "Before New Year
came in I had four of them read," she says.

And she can't get enough of her grandchildren.
"Gee, I don't mind them at all. I'm good to them – or
good to their parents maybe," she says, adding that
their arrival has helped to ease the pain of losing Enda.
She has five grandchildren. "Jennifer is six-and-a-half
(she is Feargal's eldest), Luke is six (that's Aengus's eld-
est). The next is Sarah who is four, and Sam who is
three and James who is two," she says, with great pride.

When Enda was alive, they used to holiday in the
same spot each year. They always went to Kerry, to a
place called Portmagee, at the foot of Valentia Island.
The village serves as a departure point for tourists trav-
elling to visit Skellig Michael, the island which houses
the famous sixth century monastic settlement.

"We loved it there," says Mary "So, when he died, I went back the next year but it held nothing for me. The people were lovely – I went back to stay with the people with whom Enda and I had always stayed," but it just wasn't the same. "I cried actually, several days, and I went home early."

For the last three years she has taken holidays abroad with four friends. "A husband and wife and their daughter and another guy and myself," she says. "We went to Italy the first year. Last year we went to Dubrovnik (in Croatia), and this year we're going to Portugal."

When I ask what, in her past, she is most proud of, she answers, without hesitation, "my children. I've no bother to answer that at all. Getting pregnant, having children, rearing them and now seeing their children. There's nothing to beat that. There's the old yearnings again. The oldest mum in town," she says.

And future challenges? "At my age, the challenge is to stay alive and stay cheerful and stay well and keep talking and keep meeting old friends and keep representing my people". *Vox populi* is still very much at the top of Mary's agenda.

Patricia Callan

*Patricia Callan is direc-
tor of the Small Firms
Association. A native of
Westmeath, she lives in
Dublin with her hus-
band Conor. She is one
of the social partners
involved in the annual
round of negotiations
with government.*

**"Paul chose theoretical physics. I chose
economics. Neither of us wanted the farm."**

PATRICIA CALLAN, THE DIRECTOR of the Small Firms
Association, is a native of Co. Westmeath. She
thrives on challenge and is constantly – deliberately
and accidentally – learning.

She was brought up in the town of Mullingar but the
family farm was in Delvin. Her mother didn't drive, and
had no desire to live "in the country". (She eventually

learned how to drive when she was 50 years old). So Patricia and her brother lived in Mullingar with their parents, and her father came in and out from the farm in Delvin each day. It was a uniquely Irish solution to an Irish problem. Her father farmed cattle and sheep. "He always went for the early lambing, so we always had lambs on Christmas day at home – very early!" she says.

Her brother Paul is two years older than her. When he completed his studies in Ireland, he went off to the USA to study theoretical physics for a PhD. He left when she was still quite young and never returned to Ireland to live. "It's funny how you have a sibling but, at the same time, you almost feel like you're an only child," says Patricia.

Paul obviously had no interest in taking over the farm, and neither had she. Patricia always had an interest in agricultural issues, but never to the extent that she wanted to farm. There was no pressure from the family, though. She thinks that, like a lot of modern farm families or family business owners, her parents accepted that their children might not want to do what they had chosen to do in life, and applied no pressure to them to follow in their footsteps.

Patricia didn't really know what she wanted to do when she left school. "I never really decided. The only thing I knew was what I didn't want to be, and that was all of the normal role-model type jobs like teaching and

doctor and pharmacy and all that kind of stuff, and of course I would have done work experience in all of those," she says.

She just knew that she wanted to do something "different" – oh and she also wanted to be President of Ireland some day!

She applied to Trinity College to study business, economics and social studies and specialised in economics. She had no knowledge of any of these areas, not having studied them in school. She wanted to do a "broad degree" but didn't really want to pursue any subject that she already had knowledge of. The one thing you learn quickly about Patricia Callan is that she thrives on challenge and has a low boredom threshold! As she says herself, "I always wanted to learn new things all the time. I had never studied any of these subjects in school – they were all brand new – and I was just curious."

She had aunts who were in business in Dublin, so she lived with them on Leeson Street for the first two years. She had a charmed life as a student with a handy walk to college each morning until her last year when she took rooms in college. She says that the Trinity "experience" is not about the lecturers or the subjects or the method of teaching – it is about the people. "You think it's the place, the institution, but it's actually the people you were there with that make the experience

memorable," she says, and she made some great friends while she was in college.

She had always disliked the idea of an "old boys club". "But now I have one," she says. "I see it now as a network of people who are your friends, happening to be in places that are useful for you, and that you can just ask for help." It was never something she actively set out to cultivate, but it has been very helpful to her over the years.

While she was in Trinity, she got involved in everything that she could. She edited the student newspaper. "I'd stay up all night editing the newsletter and end up going to bed when I should have been going to lectures, but it was all part of the college experience," she says. She was also involved in the Central Societies Union, and was finance officer of the Students' Union. "We had a massive debt because of previous high rise people who had left us with a legal challenge against SPUC and we had the sheriff on the door. I inherited the bill so, you know, there are consequences to your actions," she says.

She also learned to question everything that "experts" told her. "When I was in economics in Trinity we had decided that there was no way on earth that we could ever meet the European Economic Monetary criteria and that the problem of unemployment in Ireland would never be solved. It's funny that you are listening to what your professor is saying as if it is gospel and it

obviously can't be changed. And it's not that long ago either!" she says.

When she finished college she did the "milk round" – the series of interviews that all college graduates do with different companies and organisations, mostly banks and accountancy firms, who are seeking to recruit people. She woke up on the morning that she had a second interview with a bank and found herself wondering, did she really want to work in a bank? Why was she going to the second interview at all? In the end, she decided to skip it. Many years later, friends told her that the bank waited quite a while for her to arrive – she obviously had a job if she had wanted it.

From Trinity, instead of taking a "steady job", she headed to University of Limerick where she took an MA in International Studies. This involved learning about negotiation, international law, international economics and political economies. She loved it. She remembers attending lectures about conflict analysis where they were assessing Northern Ireland and they agreed with their professor that it was never going to be resolved because there was no history anywhere in the world of decommissioning as a prelude to peace. Nowadays, she takes nothing at face value.

Her classmates at UL were of mixed nationalities. Half the class were from other parts of the world, and most of the people attending the course wanted to be diplomats in some shape or form. "Even if you techni-

cally weren't in lectures, you're sitting in the pub for the entire day, you're discussing the world and that stands to you later on," she says.

She has kept in touch with those classmates ever since, and says that now it is almost impossible for her to arrive in any country where she does not know someone, or does not have a contact for someone. She has travelled extensively including the Middle East, China, Taiwan, Hong Kong, Thailand, Brazil, Argentina, Africa, Australia, New Zealand, America and Europe.

After she graduated with her Masters, she took a job with IBEC, the Irish Business and Employers Confederation. IBEC was formed in 1993 by an amalgamation of the Confederation of Irish Industry and the Federation of Irish Employers. It is a national umbrella organisation for business and employers in Ireland which offers "knowledge, influence and connections" to its membership of over 7,500 organisations. It represents most of the major employers in the state.

Patricia had done the job interview early on and, although she says she knew nothing about IBEC when she first attended for interview, she was fascinated by the work that they did and quickly became "hooked". She worked with them in the mid-west region covering Limerick, north Tipperary, Kerry and Clare. She found it amazing that, from day one, because she had the IBEC "brand" behind her, she had access to chief executives of the major companies in the area. She began exerting

influence for a community of people who needed help – and she loved it. There was a high level of local support for local initiatives which she believed would bring great success to the region. She had studied regional development and was now putting her skills to work. She was influencing or lobbying for a "no frills" airline to make regular daily trips from Shannon Airport to London. She was also trying to get the Tralee Regional Technical College on board, and she was seeking to influence new industries to locate in the region.

Once again, she found that she was taking new challenges on board. She was getting involved in employment law, human resources issues, and dealing with trade unions – all of which were new to her and all of which she developed a great interest in. She did a Certificate and then a Diploma in Employment Law with the National College of Ireland to get a better grasp of this part of her portfolio.

She spent a year with IBEC in Limerick and loved it. She is also at pains to point out that she loved Limerick city. "No matter what you hear in the media, it is a great city to live in. I loved it," she says. She left Limerick to take a new position with the Small Firms Association in Dublin.

She was probably ready for a new challenge – although she found it very difficult to leave the job as she really loved it – but her "other half" had re-located to Dublin, and that was part of the decision too.

She met Conor Nolan when they were both at Trinity College. She continued her studies there when he left to return to Ballygar in Co. Galway to look after the family business when his father became ill. He moved to Limerick to study for his primary degree when she was taking her Masters. He then moved to Athlone and, finally, when they both had a chance to live in the same city – Dublin – it seemed too good an opportunity to miss. They moved to Dublin and married.

Her work with the Small Firms Association initially drew heavily on her Diploma in Employment Law. The Small Firms Association (the SFA) has over 8,000 member companies. It is Ireland's largest small firm representative organisation and provides services to members which include information on economic, commercial and employee relations, social affairs advice and assistance, training programmes and networking opportunities.

She was working as an employment law specialist offering advice and guidance to members about holiday entitlements, redundancies, recruitment and dismissals. Most small firms do not have a HR professional, she says. They are run by owner/managers who manage the HR function typically until the business reaches about 50 employees, at which stage they will recruit someone to fill that function. There are over 40 pieces of employment law which employers need to be familiar with. In addition, they now need to have policies and proce-

dures in place including bullying and harassment, email and internet abuse and conditions of employment. It is no longer enough to obey the law – the structures and procedures must be in place.

"I think it is a barrier to recruitment actually," says Patricia. "About 100,000 of the 250,000 small businesses are individuals or family businesses and that's because taking on that first employee is a massive, massive challenge. I think if we could get more people to be less scared of doing that you'd see a lot more growth. Quite often, people have enough work to take somebody on, but they don't want to go there mentally in terms of the responsibility."

She was about two years in that position before she became Director of the SFA, assuming overall responsibility for the management and coordination of the association. During the two years she had served on numerous committees under social partnership and become very involved in the social policy wing of the SFA for a while. She was involved in everything from labour market groups to getting ex-offenders back into employment or working with various organisations in terms of the broader business input into social policy. She then found herself coming back to the hard economic side of things again.

She sees her role as an extension of a member company's management team. Often the companies need advice, or they just need someone to lend an ear and

listen to their problems. Sometimes they are in tears – literally. For that again, they often present a problem and expect an instant solution!

When the Celtic Tiger was in full swing, people were busy, literally, minding their own businesses and making money. Business owners had little interest in what government policy was all about. That all changed, however, with the economic downturn. "Now, everyone is fascinated by what's happening at national level and issues like access to credit and what the government can do to support businesses, creating and maintaining jobs" have moved centre-stage, she says.

The SFA calls itself the "voice of small business in Ireland", and she believes that, while they can never be complacent, they are doing a good job. They provide management development and training through their national centre for excellence; they lobby/make representations to government; they provide advice and guidance to small companies; and they handle "events".

The events are an important part of what they do, Patricia believes. For example, they offer speed networking evenings where a member spends 90 seconds with a company telling them what they do and vice-versa. They are guaranteed to meet 20 people in an hour. The second hour is spent socialising over a more leisurely glass of wine.

It is a way for members to meet other members who can offer them advice, buy from them or provide a ser-

vice to them. Often the networking results in members doing business with each other. The next challenge, she says, is to develop an online business network for members. "Facebook and Bebo will eventually come to the business world," she says. "We just need to be ready for it."

Patricia represents the SFA on the National Economic and Social Forum, the Management Development Council, the High Level Group on Business Regulation and the Business Europe Entrepreneurship and SME Committee. Perhaps the most demanding and fascinating part of her job brief is negotiating the social partnership deals with government. Patricia is a representative on the national social partnership agreement "Towards 2016".

National social partnership talks are always done behind closed doors and the public never has a chance to see what goes on. Patricia explains that generally the "pillars", as they are known, are kept separate from each other and they never see the other side. They never sit with each other at negotiation stage. All of the negotiations are bi-lateral. The Department of the Taoiseach acts as liaison. They only every meet the other partners at plenaries and steering group meetings.

Each social partner presents written submissions and papers. In February 2009, the SFA papers concentrated on what the government needed to be doing for the economy in terms of creating and maintaining jobs,

helping exporters, dealing with currency issues and trade credit insurance. Patricia believes that this is an efficient way of getting things done. The written presentation gives people an opportunity to agree or disagree or counter-propose based on specifics. Most times, the partners are putting issues which are specific to their members' needs. Sometimes, all of the social partners would agree on a common area of interest – like energy costs – which makes it relatively easy to get movement and action quickly.

However, there is a noticeable lack of ideas on the government side. "What is disappointing is that we have come up with a series of ideas through this process, of things that we think should be done and its easier for the Department of Enterprise, for example, to say 'no, no, no' and the reasons why. And you get to the end of the process and say, well, you're actually paid to run the enterprise agenda in this country. What are your ideas? And there are none. So they've spent all of their time and energy in saying why we can't do the things that we've suggested, but they haven't come up with any themselves. That's a tad frustrating. You have to take risks – that's the business we're in as small businesses – and certainly other European governments seem to be much more accepting of that," she adds.

In 2007 she received two awards – the Women Mean Business Award (the O_2 WMBusinesswoman of the Year) and the Network Ireland Businesswoman of

the Year award. Both awards were new that year, so she became the very first recipient of each. In both cases she was nominated by colleagues. Although she runs an awards programme herself, she would never have thought of entering.

She was surprised to win them because, although she runs the SFA, she is not in business, she's an employee. "In terms of the judges deciding to give it to me, that was difficult. I suppose I am technically running a business because you do have to pay the bills and all that kind of stuff. Even though we're not for profit, you obviously have an organisation to run. But it really did mean a lot when you're up against people who, as far as I'm concerned, are true entrepreneurs and really doing it for themselves," she adds.

She has some unresolved issues about awards which are specifically for women. She isn't keen on separate awards for women and men, but says that "we don't seem to have made the progress we should have. The whole notion of good role models for people to identify with, and for people in schools to say, 'look, I can be like these', I think that's important, particularly in the entrepreneurship area," she says.

She believes that the number of female members of the SFA has grown since she became director (although she is quick to add that she is delighted with the new male members too), and she is very conscious of gender, regional and sectoral balance across all SFA committees.

She is generally the only woman in the room and all of the research, she says, shows that men are more influential in terms of listening skills. However, she believes that if you are the only woman you are different so you are definitely at an advantage - and you have to be remembered.

"It's all about hard work at the end of the day. People who work hard, do well," she says. Most business is done between individuals. You need to know how far you can push things so that you get to a win/win situation. Personal relationships are key, "and it is important to show support for other people, even if the functions are not critical to you," she adds.

Patricia was featured in the *Irish Independent's* list of "Ireland's Fifty Most Influential Women Business Leaders" in 2008, and was included in this years *Business & Finance* magazine's "Who's Who in Irish Business 2009".

She's not a great believer in relaxing and couldn't sit in front of the television for the saving of her life.

"Every year I write a set of goals, personal goals as well as for work. Personally, everyone needs to learn and develop. If you don't say to yourself, 'I'm going to do X, Y and Z this year', you won't. It's very important to do that. Every year I try to do two new things and learn something new that's mental, and something new that's physical. It can be a bit of a hassle to have to go to Spanish class on Friday after work, or going down to the

west of Ireland learning how to scuba-dive in the bitter cold. But you feel fantastic at the end of it so it's worthwhile doing those things," she says.

This annual goal-setting began years ago when a group of schoolfriends decided that it was something they should do, so that they would always have something to look forward to. Patricia stuck with it and she still regularly swaps "updates on goals" with those friends.

She loves dancing. She was involved in Irish dancing from a young age and loves dancing of all kinds. Patricia and her husband learned to dance their first dance for their wedding, "but I realised that we had learned to dance in a way that we could only dance that one dance, with each other. We hadn't actually learned to dance at all. But we were perfect. It was really good," she says.

This year, she is taking up salsa dancing – and she is definitely bringing her husband. "In salsa it's all down to the bloke so, if the bloke knows what they're at, you look good regardless," she laughs.

The other thing she is doing in 2009 is conversational French. "I did French at the Leaving Cert but haven't done anything with it since. Instead of going off to learn a new language, which has been my trade for the last few years, I decided that I would go back and do something properly," she adds.

When asked what she is most proud of in the past she immediately says, "getting married. My wedding

day. You have to get your priorities straight. Getting married to Conor was the most memorable day and the highlight." Then she adds, "and becoming director of the SFA. I was in the Dáil on March eighth, International Women's Day, with Network Dublin, when I got the call to tell me that I'd got the job and should return for a photocall. I was the first female director of the Small Firms Association. We didn't flag it like that, we didn't talk about it, but I was very conscious of it at the back of my mind," she says.

For the future, she believes that, in tight economic times, members will review whether or not their membership is relevant, so the SFA needs to continue to retain members and sponsors, and grow membership in the coming years, and encourage risk-taking at government level. "Having ideas is good because people are listening at the moment," she says, "but getting them over the line needs investment. In this climate, where everyone is focused on cutting, that's going to be very difficult."

Patricia Callan will undoubtedly expand her knowledge of business areas as her role develops. She will continue to "relax" by setting herself physical and mental challenges each year. Her hunger for knowledge is palpable, as is her genuine passion for what she does. Agriculture's loss is the business world's gain.

Pauline Bewick

Pauline Bewick's mother kept every sketch and painting that she made, so this artist's collection of work begins at the tender age of two years old. She has painted in Tuscany, Greece, the South Pacific and Ireland. Born in the UK, she is one of our most pro- *lific and highly regarded artists. A member of the RHA, she recently donated 200 works to the state.*

"I've always been open. I'm not afraid to say if something is covered in warts."

PAULINE BEWICK'S MOTHER LEFT England in the late 1930s, with her two daughters, to foster two children in Kerry. It was all done on the spur of the moment "without any intellectual calculations on her part. That was the way she lived," says Pauline.

Her mother ran away from Pauline's father who was an alcoholic. She left Newcastle, in the north of Eng-

land, not really knowing where she would go. She left a sizeable collection of rare and antique books, one of which was a first edition of *Alice in Wonderland*, and a lot of very valuable possessions. She walked out of her lovely house, called Bat Cottage (which Pauline says, wickedly, was very suitable!) taking nothing with her but her daughters. It was a very gutsy move.

She arrived, with Pauline and her sister Hazel, to a hotel in Letchworth. Pauline's mother was actually christened Alice, but she never liked the name. While she was at the hotel she broke something, Pauline cannot remember what, and the owner said, "we'll call you Harry because you're like the gardener, Harry. He's always breaking things too". The name stuck. From then on, everyone called her Harry and Pauline called her "Mummy Harry".

The lady who owned the hotel was from Kerry. Harry had been telling her the story of what had happened to them when the hotel owner said, "why don't you run away to Ireland? I'll give you a farm if you foster two children whose parents have died". To which Pauline's mother replied, "I'm footloose and fancy free. I will. I'll do that," she said, and off they went.

Her mother had never been to Ireland. She thought it was flat. "She was gobsmacked by how beautiful the country was, and how mountainous Kerry was, and she fell in love with Kerry and Ireland and the people and it continued throughout her life," says Pauline.

Pauline and her sister made friends quite easily with the two foster children, Lucy and Michael. "We played a game called 'Tig'," she says, and it only took a matter of days before the ice was broken and they were all the best of pals.

"Tig" is the north of England name for a game known as "Tag" in the rest of the UK, or "caught" in Ireland. One child chases the others until they can touch them. The person is then "tigged" and must chase the others until they, in turn, catch someone and "tig" them.

Pauline, her sister Hazel, Lucy and Michael lived happily in the farmhouse with her mother. "It was a wonderful childhood," says Pauline. Later, her mother wrote a book about the experience. Called *A Wild Taste*, it was published by Methuen. Harry, Hazel, Lucy and Michael, sadly, are now deceased.

Pauline had dyslexia from a very young age, although it was never diagnosed until years later. Dyslexia is a specific learning difficulty which makes it hard for someone to learn to read, write and spell correctly. To this day, Pauline asks her husband to spell things for her, and dictates –rather than writes – short stories. Her daughter Poppy and her grandson are both dyslexic.

Pauline was never discriminated against in any way because of her difficulty. "I seemed to skip through life with lucky teachers," she said. Her teacher in the small national school in Dowras was a remarkable woman. "She knew that I couldn't spell so, instead of spelling

'bird', she would say, 'Pauline you're very good at draw-
ing, so you draw a bird for us' and the whole class were
very interested to see my bird on the blackboard," she
says.

Her mother was also conscious of her difficulty, but
put no importance on spelling and writing. She genu-
inely believed that Pauline was a visual person. She was
not dismissive about the dyslexia, just very practical in
her approach. In fact, she believed so much in Pauline's
visual ability that she kept everything that Pauline ever
drew from the age of two.

Her mother was also very well read. "A.S. Neill,
Margaret Mead, a lot of intellectuals of the day – D.H.
Lawrence – those were the names that would crop up in
my childhood from her," says Pauline. Alexander Suth-
erland (A.S.) Neill was a Scottish progressive educator
and author. Founder of the Summerhill School (which
is still open) he is best known as an advocate of per-
sonal freedom for children. Margaret Mead was an an-
thropologist whose reports about the cultures of South
Pacific and South East Asian peoples greatly influenced
the sexual revolution of the 1960s. (Pauline would later
seek to follow in her footsteps when she visited the
South Pacific islands). And David Herbert (D.H.) Law-
rence is perhaps best known as the author of *Sons and
Lovers* and *Lady Chatterly's Lover*.

Her mother always "had hippy people at her feet,"
says Pauline. Undoubtedly well read, her mother was

also eccentric. "She lived in a glasshouse in her final years. People would say, 'do you not mind undressing? People on the road might see you,' and she'd say, 'oh, I just boil a kettle and it steams up the glasshouse'."

Her mother had great belief in Pauline's ability as an artist, and wanted the best art education possible for her. She originally considered sending Pauline to Cork Art School but was horrified when she realised that they didn't do life drawing. They draped the models. The Cork School of Art, now the Crawford College of Art and Design, is the third level equivalent, in the south of Ireland, of the National College of Art and Design in Dublin. Her mother immediately decided that Pauline should go to Dublin where they had nude models.

As a child, Pauline lived in a variety of homes. She lived in a caravan, a houseboat, a workman's hut, a gate lodge, a railway carriage, and then a regular house in Dublin which, she says, was the most unusual part of her life.

Her mother was a vegetarian. She even opened a vegetarian restaurant in her house in Dublin. "I used to ask her, 'Why do we have to eat railway bank herbs?'" says Pauline.

The restaurant, however, had only one customer. Her mother used to "laden the table with dish after dish. And our one customer, Sheila Fitzgerald, was like a little bird and she would come up daily and sit there

and try her best to eat through this vegetarian food. It was a laugh," she says.

She spent four or five years in art school and loved it. During that time, she met her husband Pat at a party in Stephens Green. He was studying psychiatry in Trinity College. They called her the blue tailed fly "because I was wearing jeans and had a curvaceous bum" she says. They've been together since the 1950s with two separations, one in the 1960s and again in the late 1980s/early 1990s when she went to the South Pacific.

When she graduated, she went to work for Dr. Keyes in Wicklow Street. There she painted artificial eyes. She would have the iris on a card and she would copy the eye of the patient. "I would draw the little stripes and squiggles of an eye, and it would be put in a plastic container, boiled and popped into an artificial eye and into the patient," she says. She did one after another, all day long. During her time with Dr. Keyes, she was sent to England, to study the permanence of colours. She really enjoyed the course and learned a lot, she says. She came back and "some of those eyes went on being the right colour for years. But the ones I did before hand? I met someone on a bus and he said, 'hello, you're the person who painted my eye', and to my horror it had faded terribly," she says.

She stayed working in Wicklow Street for about two years. Then, in 1952 she saw an advertisement looking for students to paint lions and unicorns for the coronation of Queen Elizabeth in England. King George VI

died in February 1952 after 16 years on the throne of England. His daughter, Elizabeth, succeeded him as Queen. She was 25 years old. Her coronation, which was held in June 1953, was the first major outdoor event televised by the BBC. Street parties were held throughout the UK as people crowded around television sets to watch the ceremony. An estimated three million people lined the streets of London to catch a glimpse of the new monarch. Pauline went over to London and "I painted one golden lion and unicorn after another, up in the sun, on the roof of a commercial art building".

After that, she painted beads for a woman who strung arty beads, and worked as a waitress for a while, before she landed a well-paid job at the BBC writing stories for children's television. She always told good children's stories and does to this day. Her grandchildren are always asking her for them and she likes dictating them. "God forbid, if I went blind, I would be a writer and tell stories," she says.

One of the stories that Pauline wrote was about Little Jimmy, who met a centipede who was an artist and used all his legs to paint. Little Jimmy went to Cid Centipedes exhibition, where he met Cid's sister. "He said, 'hello, what do you do?' and she said, 'Oh Cid is the clever one, I just knit'." Pauline wrote that in the 1960s. "When I read the scripts years later, I couldn't believe that I would have written such an extraordinary thing," she says. "I guess it reflects the times that I was living in."

She made a lot of money when she worked with the BBC, and used it to take off with friends around the Mediterranean in a boat. It was the first time she had travelled outside of Ireland and England, and she loved it. She sketched and painted all the way, and lived on cheese and bananas.

They travelled around the Greek islands. There are actually over 6,000 Greek islands, only 227 of which are inhabited. The best known are Crete and Rhodes. "There was great atmosphere there," she says, "and I was picking up on things. Not through education, I don't know geography well – but in the huge outdoor theatres, there's an enormous atmosphere that lingers there. I was picking up huge inspiration from these Greek ruins," she says.

It was the 1960s, and it was also her first "brief falling out with Pat". "I fell in love with a Greek fellow and crashed glasses around the floor when I danced. It was marvellous," she says. "I'm lucky that, in my marriage, I've had breaks which brought me experiences. That would not have been possible if I had been married to a prejudiced man. I had the pleasure of falling for a Greek, realising that it was over, and going back to my Pat again," she says.

Pauline has two daughters, Holly and Poppy. "You shouldn't have children to please a man," she says, but "it's something that I did myself. But, at the same time, I did think that if I passed the baby producing years, I'd

regret it, so I went ahead and had two babies and thank goodness I did," she says. Both of her daughters are "brilliant artists", she says. "My one regret is that they are not as well known as I am, but that's because they're not big show offs!" she says.

Pauline's mother didn't like the fact that she was getting well known when she grew up. "She said, 'you're sticking your head out and look what happens to people who do that', and she mentioned people like (Mahatma) Gandhi and all of the people that had been assassinated. I think she thought that I'd be in real trouble," says Pauline.

When it was just mother and daughter their life was heavenly and her mother had always offered her wonderful encouragement. But once she'd grown up and had babies and was showing her work to the public, "she turned against me. She was too puritanical for that, even though she was a wild woman. Basically, when you're puritanical, you don't go out there and show off, which I was doing. I suppose, to put it in an old-fashioned way, it was unladylike. I should have been more modest. It probably was a deep down cultural thing. She disapproved of me going out into the public arena – I was being a prostitute in her eyes," says Pauline. "There were a few little tiny, nippy things like that in my mother that didn't add up."

Pauline's mother had kept everything she had ever drawn from the age of two. "It didn't appear to be

much," says Pauline. "My mother was not a hoarder. She never kept anything else. But she did keep these 1,250 pieces of work which she carried around with her in a leather suitcase."

The pieces were all exhibited in 1985, in Pauline's 50th year. The exhibition, which was held in the Guinness Hop Store, in the heart of the Liberties in Dublin, was called "Two to Fifty". When they were framed and on the walls the collection filled three floors. Her mother looked at it when it was all mounted and said, 'Oh God, to think I'm the reason for all this.' She was disgusted at herself," says Pauline.

Pauline loved the reaction to her work. Little children adored the child work. "Look mummy a horse – I can do that," they'd say. The adults also gave great feedback. One of Pauline's paintings was called "Pregnant Again". It shows a pregnant woman on her hands and knees, looking pretty disturbed and miserable, with hormones raging around her. Pregnant women who looked at the painting said, "that's exactly how I feel," and young mothers looking at it said, "you really paint how women feel when they get pregnant". It was a real compliment to her work.

After the exhibition in the Guinness Hop Store, she was ready for a trip to the South Pacific islands. She remembered all of the stories about Margaret Mead and her time there, and wanted to visit the same islands. It didn't work out as she planned.

Her husband Pat couldn't get time off from the Southern Health Board "and I couldn't bear to think of cancelling the whole thing and staying. I had bought all my paints and everything, and I was ready to go. It would have been such a terrible let down to me," she says. It was her second parting from Pat, "but we parted unconsciously," she says.

"I also cried bitter tears because I had been looked after by my mother and my husband and now I was thrown out into the world completely on my own," she says. She didn't think that her two daughters would be interested in going with her because they had boy-friends. But, to her surprise, they said they'd love to. "I had made some money, so I said I'd treat them and off we went." Poppy was in her early 20s and Holly was in her late teens. The three women embarked on a Polyne-sian adventure of a lifetime.

The name Polynesia comes from the Greek word *poly* (many) and *nesos* (islands). The Polynesian trian-gle stretches across the Pacific from New Zealand to Easter Island and north to Hawaii. It includes French Polynesia (of which Tahiti is part), Pitcairn, Easter Is-land, the Cook Islands, Niue, Tonga, American Samoa, Samoa, Tokelau, Wallis and Futuna, and Tuvalu.

As three females on their own, they were welcomed into the families of the Maori people. If a man had been with them, he would have been regarded as their "minder" and they would have been treated as a unit

and left on their own. As a mother and two daughters, however, they were asked everywhere and thoroughly embraced the Maori way of life. "It was really very educational," Pauline says.

They spent a year there initially. Pauline came back and showed her paintings to her publishers who said they loved the paintings and would publish them. They didn't want any more. But, they said, they would love the story behind the paintings. So they gave her £10,000 and sent her back to write the story.

She had kept a sort of diary while she was there. She had written notes in her sketchbooks, but there wasn't enough for a book. So, she went back, on her own this time, and retraced her steps. "I hadn't had my fill yet. I wanted to go back," she said. "I became like an amateur anthropologist. I retraced my steps to the Tahitian, Samoan and Cook Islands" and she saw things that she hadn't seen the first time.

She was there for almost three years in the end. She grew to see a violence that she hadn't picked up on initially. The film *Once Were Warriors* (1994) about a Maori family shows how violent they can be, she says.

When she saw their coconut houses, and corrugated tin houses, with walls knocked down and holes in them, she just thought it was the weather. "It turned out that Mo and Na, the two Aitutaki people, would be having the most almighty fight," she says.

She painted one woman who was walking down the beach in a lava-lava (a long cloth wrapped around her) with beautiful dark skin, bare feet, long shiny dark hair, a crown of flowers on her head and a baby in her arms. It was a heavenly scene. When Pauline got talking to the woman, a different story emerged. She said, "I can't go back in there mama. He's just been drinking. He'd kill me. He'd beat me up." So, the woman would walk the beach until her husband slept it off, and it was a regular thing.

She didn't witness the violence and yet she was in the homes of the Maori people a lot. "They don't have an enzyme to absorb alcohol of our kind," says Pauline. "They can take Kava, which is, in fact, made of ginger root. It numbs the body and doesn't send them crazy. German doctors use it to knock people out before operations. With our type of alcohol, it boils their blood and they become incredibly violent," she adds.

She also spent time talking to people and asking them to translate for her. A schoolteacher translated a song about a church that was divided in the village. There were two carpenters in the village and each of them wanted to decorate the church. No one could decide what to do for the best. In they end, they decided that both should design the church – one half each. The priest would put one foot in one side and one foot in the other when he spoke from the pulpit. The church is on

Atiu, on of the Cook Islands. "It's a hoot," she says, "one side is totally different from the other".

Her mother had often spoken about Margaret Meade and the South Pacific and Pauline had almost expected to find the perfect society there. She didn't.

Before she had gone to the South Seas, she had been sad about war. "I suppose I blamed men for war. Later I realised that women were just as warlike by bringing up their boys to be heroes," she says. She had done some sketches in Tuscany in central Italy before she left, and now she returned to them.

She had been sketching a little yellow man, naked, with antennae, in the vineyards and the local children next door to her daughter's house just loved it. They said, "uomeni jallo, encore", so she did many, many more yellow men. When she came back, she realised that this little yellow man had got something special. "He lives a silent life like a perfect being. He's non-judgemental, naked without shame, interested in nature and interested in all that goes on around him. He's not violent. He's also very silent and he's a worker – he plants his seeds and eats the food that's grown," says Pauline. In 1996, she developed a whole series of paintings for an exhibition at the Royal Hibernian Academy (RHA), and she wrote a book about it.

To her joy, her friend Seamus Cashman of Wolfhound Press published the book. (Wolfhound Press was established in 1974. It became part of Merlin Publishing

in 2001). He said he would publish it, even though there was no "shelf" that it really fitted on. "It's neither for children nor for adults. It is sort of philosophy. Bookshops won't know where to put it," he told her.

"Since then, anyone who's met the yellow man in the book or seen him in the paintings always asks, 'what's happening with the yellow man?' He really made an impact," she says.

Pauline has been developing philosophies over a number of years now. She's always had a big hangup about overpopulation and unwanted children. She believes every child should be wanted. "The world is overpopulated and I think contraceptives should be thoroughly dished out to people. There are far too any unwanted babies. Obviously, a wanted baby is going to be healthy, psychologically. A well adjusted human being," she says.

In recent years she has also been developing her theories about world government. "I believe we'd be far better off if we were governed by people from all over the world. Say under Barack Obama. There would be no such thing as a butter mountain. And there should be a focus on producing things," she says. "If only there could be an incentive to make a lazy person give something."

And she has a philosophy about marriage. "We must never consider, within our marriages, that if we leave, for one reason or another, it doesn't necessarily mean

that you can't get back again. I've seen many the marriage that has broken up, and they've done it permanently, when they would have been so happy getting back together, but pride has kept them apart," she says, adding that, the last time she and Pat split, it was Dr Shanahan, a marriage therapist, who got them together. "I wasn't keen on going," she says, "but we ended up laughing ourselves silly. We realised that we are two very different people, Pat and I, but we have a great sense of humour alike and we got back together again and very happily."

Nowadays, she does a tremendous amount of exchange. She was looking for natural stone slabs recently. This man came to her. "I love that painting," he said. "How many slabs would that be?" She told him and they swapped. She now has the slabs that she wanted, and he has a painting which he will always admire. "It works beautifully for me," she says.

Pauline also donated 200 paintings to the state which were accepted, on behalf of the Irish people, by President Mary McAleese. One collection of paintings is on permanent view in Waterford Institute of Technology. A second collection is permanently on view in the Kerry County Council offices in Killorglin, and a third collection will travel the world.

Pauline is very modest about it all. "To tell the truth – it's given me space in my studio. I'm so prolific and I'm painting now, bigger than I ever did. And I'm paint-

ing more – I'm so enthusiastic. And the fact that I've
given those away was an utter pleasure," she says.

Her greatest challenge for the future is "to be happy
in sadness. As one grows older certain things are hap-
pening to my husband. His memory is going a bit. Doc-
tors have told him, 'just enjoy what you are doing, don't
feel anxious that you have to understand everything',"
she says.

"To be open to my friends and to Pat about this,
which is a problem. To accept it and to deal with it. It
started with anger. I'd say, 'have you forgotten that al-
ready?' And all that anger is from worry," she says. "So to
quickly learn that you've got to have an understanding of
things and get great pleasure out of things and not to see
the gloomy side." That's her challenge for the future.

Her mother was always incredibly truthful. Not in a
sanctimonious way. Not in a hurtful way, but she just
came out with it, and you always knew precisely where
you stood. And it is that quality that Pauline is most
proud of, in herself. "That I've always been open with
husband, children, mother, everybody. I'm not afraid to
say something that's covered in warts," she says.

Pauline Bewick is one of the few people you will
meet whose life, really is, like an open book. This tal-
ented artist is refreshingly open about her life and in-
credibly willing to tell you about things that you haven't
even asked about.

Veronica Dunne

Veronica Dunne – widely known as Ronnie – is one of Ireland's best-known opera singers. Her career was launched when she won the prestigious Concorso Lirico Milano competition. This led to a contract with the Royal Opera House in Covent Garden, and performances on *opera stages throughout the world. When she stopped singing, she began teaching at the College of Music. She founded Friends of the Vocal Arts in Ireland and is the creator and driving force behind the Veronica Dunne International Singing Competition.*

"Don't get married if you want a career."

In 1953 two iconic figures – Joseph Stalin and Maud Gonne MacBride – died. *Peter Pan* was the big movie in cinemas. Dwight D. Eisenhower succeeded

Harry S. Truman as President of the USA. The 25th. Academy Awards ceremony became the first to be broadcast on television. Dag Hammarskjöld became Secretary General of the United Nations. Ian Fleming published his first James Bond novel. Sir Edmond Hillary and Tenzing Norgay successfully ascended the summit of Mount Everest. The European Economic Community (EEC) held its first assembly in Strasbourg, France. REM sleep and the structure of DNA were discovered. Hugh Heffner published the first issue of *Playboy* magazine. The Korean War ended and Veronica Dunne, the Irish opera singer, married her childhood sweetheart.

Veronica Dunne's mother didn't speak to her from the night she got engaged, until the night before her wedding. It wasn't that her mother disapproved of the groom. Instead, her mother felt that it was entirely wrong for a woman who wanted to keep her career to also want to get married. Ronnie (as she is widely known) was a highly regarded, much sought-after opera singer who used Ireland as a base, but sang mainly in Covent Garden and throughout Europe.

Ronnie married Peter McCarthy in 1953. They had first met ten years earlier when she was 16 years old. Her mother utterly disapproved of Ronnie getting married. "In fairness, mother could see how difficult it was going to be for me and she really was annoyed. She walked out of the house on the day I got engaged and

didn't speak to me until the night before I got married. And she said, 'I hope you don't live to regret it'. It is so impossible to have a career in singing and travel to wherever you have to travel. Singing is a lonely career and trying to keep up at the top and have children and live a normal life – it's very difficult. She could see what was ahead not only for me but for the man I was marrying."

"You know, it's a funny thing. I met my husband when I was 16 and fell madly in love with him," she says. They were married ten years later when she was 26. "I was away so much really that, with hindsight, in fairness to the man, he didn't realise what he was marrying," she adds.

It is hard now to imagine how difficult it was for her at that time. Today a woman's right to a career and family life is accepted as a "given"; that was not the case in the 1950s. Ronnie's singing was, by the socially accepted mores of the time, expected to take a back seat to her family commitments, particularly when her two children were born.

She continued with her full-time career for the first ten years of her marriage, until the children reached their teenage years and she found that she simply could not continue.

"I was always very organised," she says. "I had a good nanny, Margaret, and a good housekeeper and I was very good at organising. But Peter had his racing and his pals. He had his life too. When I look back on

it, it must have been very hard on him. He went his way and I went mine." To this day – 55 years later – she advises her students who want a career – "don't get married".

Ronnie Dunne was destined to be a world-class performer from an early age. She was born in Clontarf, on Dublin's northside, into a very musical family. Her father was a fine baritone. Her mother had a good voice, but not a great one. Ronnie says that "my father had a most beautiful baritone voice and all his brothers sang. Daddy used to sing 'The Heart Bowed Down' and mammy use to cry in the corner!" ('The Heart Bowed Down', from *The Bohemian Girl* opera, was a very popular song for baritones at the time, made famous by the American singer John Charles Thomas.)

Ronnie is undoubtedly the most famous singer of the three children, but her late brother Bill had a fine tenor voice and her sister May is a mezzo-soprano.

Favourite night in the family home in Clontarf was Thursday, when there was opera on the radio from Milan. The children were allowed to stay up late, and the whole family listened in.

During the winter, the family held monthly evenings at home to which they would invite other family friends, and would entertain each other by singing songs and reciting poetry. It was a circle of friends that moved from one house to another, each doing their party piece and all thoroughly enjoying their evenings out.

At one of these evenings, Ronnie sang and the family realised that she had potential. Her brother was already attending Herbert Rooney, who was well known in Dublin as the trainer of the Bel Canto singers. They sent Ronnie too and this was where she began training her famous voice. She was "hooked" instantly!

Ronnie was never shy. As a child, she loved being centre-stage and these family evenings were never going to be enough for her. Limelight drew her and she absolutely adored performing. In fact, in true Ronnie style, she created her own performance outlets.

As a young girl, she would construct a stage in the "theatre" of the family's garage at home. "I had the intelligence, I was very young, seven or eight, to get bicycle lamps to light the stage. When I think of it. And I used to run away with mummy's sheets to have them for curtains!" she says.

Ronnie wrote all the plays herself– in another life she could have been a playwright – and always gave herself the staring role – naturally. "I used to write the plays and I picked my own friends the Egans, the Meegans and the Cooks. We used to get Marietta biscuits and red lemonade for ourselves," she added.

She showed great entrepreneurial flair even then, charging an entrance fee of a farthing to cover the costs of their "goodies".

She was also a keen horsewoman who had her own pony and competed at gymkhanas and showjumping

events in the RDS. She won many medals and trophies and might have been Ireland's first international equestrian star but for the lure of the grease-paint.

Ronnie says that her mum was very strict with her. "I was very wild"' she says. "I should have been a boy. I really should have been a boy. I was a tomboy. I climbed trees. I rode horses. I used to hunt. I had no fear."

She hunted with North County Dublin and the North Kildare Harriers. "I even hunted with the Wards, and my God they're tough," she said.

She believes that her mother sent her to boarding school in Mount Anville in the hope that it would knock some of the tomboy out of her.

Ronnie adored singing and desperately wanted to advance her career by studying in Italy. She asked Mother Bodkin, the Mistress of Studies at Mount Anville, to write to the mother house in Milan and see if they would let her come. The sisters in Milan wrote back that it was not safe and under no circumstances should she come.

But Ronnie has always been lucky. "A planned life is a finished life," she says. "As I always tell my students, when your boat comes in, when your luck comes in, you have to go with it."

As it happened, Father Campion, the parish priest in Kill, Co. Kildare, heard of her plight and invited her to lunch to meet Delia Murphy. Delia was a famous Irish

ballad singer at the time, and the wife of the Irish am-
bassador to Italy.

Monsignor Hugh O'Flaherty arrived quite unexpect-
edly and joined them for lunch. Ronnie knew nothing of
him (he was quite famous at the time) and had only a
vague understanding of the war. She knew that there
had been a terrible war, but knew very little of the
atrocities or the incredible bravery of individuals, in-
cluding Monsignor O'Flaherty.

This was 1946, just a year after the end of the Sec-
ond World War and the fall of Benito Mussolini, Italy's
fascist dictator. Monsignor O'Flaherty was known as the
"Pimpernel of the Vatican". Born in Cork, he had saved
about 4,000 allied soldiers and Jews by hiding them in
flats, farmhouses and convents in Rome, where he was
based during the war.

He was also a lover of music and he took a great shine
to Ronnie. He told her that he agreed with the sisters.
Milan had been flattened and there was no way that she
could go there – but he suggested that she should go to
Rome instead. Her family were very concerned for her
safety and would not hear of letting her go. Monsignor
O'Flaherty visited her parents and assured them that he
would look after her – and they gave in!

Now Ronnie was faced with the issue of raising
enough funds to get there. Never one to be daunted by
"minor" details, she sold her beloved pony for £125. At
the time, there was a tradition that the buyer gave some

money back to the seller and this brought good fortune to both of them. "I was so reluctant – for luck money you had to give back the £5. I wasn't going to give it back because I could see that money paying for a lesson, but my father stood over me and said, 'you give that back or you won't get anywhere'. So I made £120."

However, the £120 wasn't going to get her very far. She needed about £50 per month if she was going to take lessons – and that raised another problem. At the time, the Irish government only allowed its citizens to take £125 out of the country in any one year.

Unphased by this, Ronnie went to see Sarsfield Hogan, the Secretary to the Minister of Finance, to put her case. "Once I made up my mind to do something, I was a little bitch to be quite honest! I would go through the wall to make sure I got what I wanted," she said.

Hogan was very strict with her. "He said, 'well, if we allow you to take so much money out the country, what are you going to do? Are you going to go off like so many singers around the world and never pass it on?'" What a challenge. There and then she gave him an undertaking: "I swore – I promise you I'll come back and pass on what I have learned," she said.

Ronnie believes that, of all the people who ever left Ireland at that time, she has, undoubtedly, fulfilled her promise, brought back skills and passed on what she learned.

Ronnie moved to Rome and began her voice training in earnest. She studied first with Contessa Soldini Calcagni, and later continued her operatic training with Maestro Francesco Calcatelli.

In 1948, Ronnie made her debut in Dublin singing Micaele in *Carmen* at Christmas and Marguerite in *Faust* the following Easter with the Dublin Grand Opera Society.

In 1952, Ronnie entered the prestigious Concorso Lirico Milano competition. The preliminary rounds were held every month from February to June of that year and Ronnie travelled from Rome to Milan each month to compete. The competition attracted 200 sopranos.

Ronnie was in Sligo performing a symphony concert when her parents got the word that she had been selected for the semi-finals. Her brother Bill drove to Sligo to collect her, but his car broke down in Athlone on the return journey so they had to get a taxi back to Dublin. When she got home, she had just enough time to pack her bags – she never got to bed – before heading off to the airport for the flight to London and then on to Milan. She was on stage at 5.00 pm that evening singing in the semi-final. It was well worth it. She made it through to the finals and won the competition – and it launched her career.

Sitting in the audience that night were Sir David Webster and the Earl of Harwood. They were so taken

with her obvious talent that they offered her a contract with the Royal Opera House Covent Garden. That was June and she would start in Covent Garden in September.

In the meantime, winning the competition meant that she had won herself the role of Mimi in *La Boheme* and she made her debut at the Teatro Nuovo in Milan that summer.

But she also wanted to perform *La Boheme* for the Dublin Grand Opera Society (DGOS). Earlier in the year, Bill O'Kelly and Bertie Timmins from the DGOS had travelled to Rome to meet her. From there, she travelled with them to Milan to meet the agencies and choose the singers. With the help of the Angeloni agency in Milan each individual singer was chosen.

So, over that summer, Ronnie brought the first ever tour of Italian opera singers to Dublin. Between 20 and 25 Italians arrived on tour in Ireland, "but unfortunately, the hotels and restaurants were on strike that year. My father and mother, bless them, had an open house for the Italians. And I can tell you, between the wine and the spaghetti, we let them take over the kitchen and there was spaghetti coming out the windows. We weren't really, cuisine-wise, adapted for Spaghetti Bolognese. They wanted their spaghetti and mum and dad very kindly opened up the house to them," she says.

In Covent Garden that September, Ronnie made her debut singing Sophie in Strauss' *Der Rosenkavalier*.

"They made a great fuss of me when I went there," she says. There were many well-known Irish singers at the time. "Renee Flynn, Patty Black and May Devitt all had gorgeous voices," she says, but none had a contract with Covent Garden. Ronnie was the only one.

Margaret Burke Sheridan was at her first performance. Puccini had gone through *Boheme* with Burke Sheridan offering her advice, guidance and insights into his work and how it should be interpreted. Margaret Burke Sheridan was so taken with the young opera star that she went through *Boheme* with Ronnie in the same detail that Puccini had done with her.

Ronnie continued to perform and sing at Covent Garden for the next 20 years, during which time she became firm friends with Dame Joan Sutherland and the two are best buddies to this day.

In 1954, the year after she was married, she did a three-month long tour of America, with the first ever "festival of Irish Singers", and appeared on *The Ed Sullivan Show*. *The Ed Sullivan Show* – or *Toast of the Town* as it was called then – was in its eighth season. It was one of the most influential television shows of all time in the USA and was famous for the musical acts which featured on the programme including (later) Elvis and the Beatles.

It was hard work travelling America in a bus – but it was also great fun. "Ed Sullivan saw me," said Ronnie. "I was a red headed woman and it was a black and white

television. And he said 'no - that won't do. Go and see Michelle of Paris' – there was always a Michelle of Paris or Brussels – 'and he'll fix your hair'. I went along and Michelle said, 'right, I'll do a job on you'." And what a job he did. "He dyed my hair white," said Ronnie. "I was like Harpo from the Three Stooges – then they put a rinse on your hair afterwards and I was a strawberry blonde!" It was the only time she sang Danny Boy as a blonde!

She continued to perform at Covent Garden, working with the National Theatre Company for the next 20 years, adding to the glory of her reputation playing not only in Covent Garden but with the Welsh National Opera, the Scottish National Opera, Sadler's Wells (now ENO), and the Wexford Opera Festival. But she had to reduce her level of commitment because of her children. "Whey they go to secondary school you have to give up, you can't do it, it wears hell on you," she said. "It takes the whole energy and emotion out of the voice. They need you more as they get older. It's easier when they are younger and you have a nanny," she said.

The reduced commitment brought new opportunities, however, and by the time she had retired from the stage in 1973, she already had 10 years teaching experience behind her. Michael McNamara, who was principal of the College of Music, had invited her to start teaching with them in 1963 – just a half-day a week on Thursdays. That grew into Saturdays and Mondays and

before she knew it, she was practically teaching a full week. She is still as busy teaching to this day.

Ronnie has a natural ability to spot talent and a straightforward, non-nonsense style of telling you if you have none! She instinctively knew if a sound was wrong. "I developed my own exercises to help develop their voices," she says about her pupils. "You get a voice that sings through the nose and one down the neck. If a voice is on the nose I needed to bring it into the mouth; if it was down the throat you bring it towards the nose. I know immediately by the sound of the voice if something is troubling them," she adds.

"You act by sound. You become part of them. You know exactly where they are putting their voice wrong, and you explain exactly what they are doing wrong – they're lifting their tongue, choking themselves in the neck, their jaw is too tight, their neck is too tight, the breath is too high, it has to be down further in the body so that they coordinate the diaphragm and the head voice together," she explains.

She does much more than teach her students. She becomes a part of their lives. "I own them," she says. "They get very sad when they leave me, but I tell them all you need now is coaching. I have done everything I can for you. Go and learn the tools of the trade. Go to an opera company."

And she is so proud of them and their achievements. "I trained Suzanne Murphy for two to three hours every

day for three years and she went straight into the Welsh National Opera Company," she says. She also mentions Tara Rock, Deirdre Delaney, Edith Forest, Mary Brennan, Sylvia O'Regan, Linda Lee and Anne Murray. Many of her former students have a career and are also teaching her techniques, and that gives her great pleasure.

She teaches her students, but she also encourages them, helps to mould their careers, makes opportunities for them to perform, helps them financially, and has even taken them into her home. She becomes a huge influence in the life of any student who has ever studied under her tutelage.

From the time she first began teaching, Ronnie was conscious that many of the students had real talent but were in serious need of financial help and assistance. When she retired, her students gave a concert for her and raised €20,000. Ronnie formed the Friends of the Vocal Arts in Ireland and donated the €20,000. That was only the beginning.

Not content with teaching these students and making sure that they were financially secure while they studied, Ronnie decided that there really should be a platform for students to showcase their talent. She created the Veronica Dunne International Singing Competition in 1992. Originally offered as an Irish competition, she was afraid that "it was becoming like the Feis", so she made it an international competition instead. It quickly attracted entrants from all over the world and

has built quite an international reputation based on the calibre of past winners. Ronnie is not involved in the judging process and really only meets the judges on the last night so that her influence over the choice of finalist cannot be questioned. She has none!

Which is just as well, since three Irish singers always seem to make it into the final, and she is equally proud of their achievements. "Naomi O'Connell is now in Julliard," she says, "and Celine Byrne, who had pneumonia on the night she performed, has just won the Maria Callas in Greece."

She has seen big changes over the years, not least in the number of sopranos who want to earn their living from their voices – there are now nine million sopranos worldwide. Not all of them will succeed. "Producers are very naughty," she says. "They want the full package – they want you to have a face like Mona Lisa or Marilyn Monroe, and a figure like a model and be of a certain height, and you must be a first class musician. That's why I'm very hard on them. It's tough out there," she says.

The one big bit of unfinished business, in Ronnie's eyes, is the lack of a National Opera House in Dublin. She is horrified that we don't yet have one. There are internationally renowned opera houses throughout the world – the Sydney Opera House in Australia, the Vienna Staatsoper in Austria, the Royal Opera House in London and La Scala in Milan – but none in Dublin.

For a country as small as Ireland, some would argue that we actually have our fair share of opera houses. The Cork Opera House and the Grand Opera House (Belfast) are long established, and in recent years the new Wexford Opera House was opened.

Ronnie will hear none of it. She firmly believes that Dublin should have its own opera house. And, in fairness, Dublin has had a long association with opera. Long before the Dublin Grand Opera Society began performing in the Gaiety Theatre in the 1940s, there had been regular visits by the celebrated Moody Manners Opera Company, the Carl Rosa Opera and the O'Mara Opera Company. The Gaiety has hosted performances by Pavarotti, Salvini, Joan Sutherland, Bernadette Greevy and, of course, Veronica Dunne.

As a member of the board of the National Concert Hall, she had been really hopeful that the second auditorium, which has received government approval, would become an opera house.

"We should have an opera house in Dublin. It's very sad. We do have the Gaiety which is wonderful. But I was really hoping that the second concert hall that they are building could be like Salzburg, which is a concert hall but it's also an opera house," she says.

"You could bring in visiting opera companies. We could have an opera studio and have our young people singing in opera and they would travel. We could introduce exchanges with Glyndebourne (Opera House),

Scottish Opera, the ENO, Dresden and Leipzig. And we have our youth orchestra and they could be the orchestra for the opera. The singers who don't have the voices to be lead singers would sing in the chorus."

The whole idea comes alive when Ronnie starts explaining it. She is also a realist and wonders why, in times of recession, this income-generating proposal isn't being seriously looked at.

She mentions Salzburg again, where "they have a car park underneath where you can drive straight in and come up into the auditorium. Wouldn't you pay €10 for that? But the corporation have turned it down (for Dublin). They don't think of the revenue they could get."

And she believes that such a project would also generate income for the government. "The singers would pay their taxes, the orchestra would pay their taxes. Really, in a recession I wonder who is running the government?"

Veronica Dunne is a patron of the Dublin's Lyric Opera, a former board member of the National Concert Hall, and an honorary life member of the RDS. She received an honorary doctorate from UCD in 1987.

For a woman who lives her life very much in the public eye, she is also a dedicated homemaker. "I'm a good cook and a good housekeeper. I'm like a sergeant major. I'm like that woman on the television, Mrs. Bucket," she says. (Hyacinth Bucket – pronounced bou-

quet – was a popular character in the BBC sitcom *Keeping up Appearances* in the 1990s.)

"I'm very fussy. Everything must be clean. The silver must be shining. The furniture must be bees-waxed. The net curtains must be washed twice a year. Every two years the heavy curtains must go to the cleaners. I'm very lucky. I have a very good gardener, Richard, who is 22 years with me and a great housekeeper, Clare, who is 20 years with me. I adore them both. They are family," she says.

She relaxes by watching current affairs on television – news, primetime and documentary programmes – and believes her greatest achievement is her teaching.

Veronica Dunne was 81 years young in 2009. She is an inspiration to all who know her.